NICKY HILTON

with ALLIE KINGSLEY

365 STYLE

3-6-5 STYLE

ISBN-13: 978-0-373-89297-6

© 2014 by Nicky Hilton Design, Inc.

Photography : Istock Vectors/Getty Images – page 39

Istock – pages 40, 51, 60, 63, 71, 81, 93, 100, 136, 137, 144, 155, 160, 163 & 200

Andrew Eccles – cover, pages viii, 10, 18, 20, 28, 32, 35, 36, 56, 62, 72, 75, 88, 91, 94, 98, 102, 105, 107, 113, 117, 118, 131, 156, 170, 184, 202

Stylists: Wardrobe: Logan Horne, Makeup: Chris Colbeck, Hair: Adrian Clark

Library of Congress Cataloging-in-Publication Data

Hilton, Nicholai Olivia, 1983- author. 365 style / Nicky Hilton with Allie Kingsley.

pages cm

Includes index.

ISBN 978-0-373-89297-6 (hardback)

1. Clothing and dress. 2. Fashion. I. Kingsley, Allie. II. Title. III.

Title: Three hundred sixty-five style.

TT507.H55 2014

746.9'2--dc23 2013042350

www.Harlequin.com

Printed in U.S.A.

CONTENTS

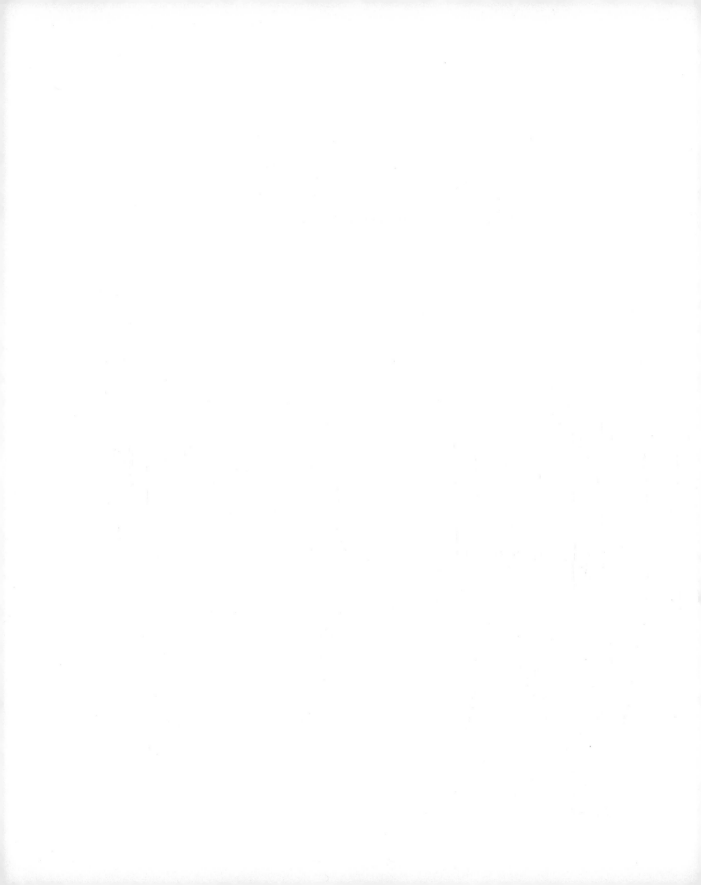

INTRODUCTION
365 STYLE

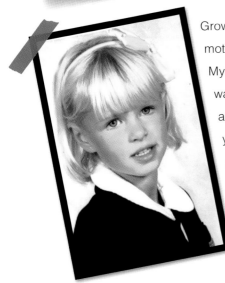

I always **knew I** wanted to do something in fashion.

Most young girls are unsure about what they want to be when they grow up. Some want to be a nurse, others a lawyer, chef, therapist and so on. I never had that problem. I always knew I wanted to do something in fashion. Anything! I loved the magazines, the supermodels that were splashed across the pages, jewelry hunting, shopping for clothes, purses…I was literally entranced by anything that had to do with fashion.

Growing up, I remember being picked up from school by my mother to tag along on the occasional trip to Neiman Marcus. My older sister Paris would pout over the excursion. She would wait at the valet and annoyingly ask, "When are we leaving?" and then come find my mother every so often to persist: "Are you done yet?" I, on the other hand, would gladly accompany my mother into the shop and look at everything on the racks in complete awe. My big blue eyes would widen while watching her try on the beautiful shoes and clothes. I loved it. I could sit there for hours.

VI To me, fashion is fun and exciting, but it is also an opportunity to identify and express myself. Your wardrobe choices say so much about you. I don't mean that in a shallow way. Your style says so much about your personality and lifestyle—it's a means of self-expression, not to mention that the first opinion people have of you has to do with what they see. We are constantly making first impressions, even when we don't realize it. What do you want your appearance to say about you? It is only human nature to judge a book by its cover, so why not make yours a best seller?

My first selfie!

At the age of sixteen, my years of fashion obsession were recognized when I earned myself a spot on Vogue's Best Dressed in America list. At the time, I didn't really understand what it all meant. All I knew was that the editors of Vogue were coming to my family home at the Waldorf Towers in Manhattan with racks of designer goods to photograph me for their magazine. I came home from school the day of the photo shoot and in true Cinderella fashion a team of makeup artists and hairstylists expertly transformed me into a model. Just when I didn't think it could get any better, none other than André Leon Talley himself swooped into my bedroom like a fairy godmother with a flock of assistants and what seemed like endless racks of designer gowns in tow. Chanel, Gucci, Prada, Christian Dior—you name it, they had it! I shyly introduced myself and we browsed the racks together.

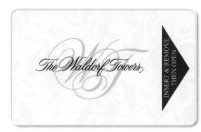

It took years of experimenting, plus trial and error, to find my personal style.

This book is not designed to show you how to dress like me, but rather how to dress like the best version of you.

André pulled out a stunning Oscar de la Renta gown and decided that was the one. We shot for a few hours as André not only styled me but also taught me how to pose. I was young, awkward and shy. I remember the photographer kept telling me to smile and put my chin up. When my father came home from work in his suit, he went around and introduced himself to the team. In retrospect, it felt almost ordinary, yet it was far from it.

While I always knew that I loved fashion, I didn't always have a firm grasp on my own style identity. As it does with everyone, it took years of experimenting, plus trial and error, to find my personal style. Growing up, I was fortunate to have access to some of the world's most celebrated purveyors of style and the opportunity to learn from them. My early exposure to runway shows and relationships with designers inspired me and taught me to appreciate and understand fashion and style. In this book, I'd like to share those valuable lessons and style tips with you.

This book is not designed to show you how to dress like me, but rather how to dress like the best version of you. Think of it as a color-by-numbers book where you get to decide on the digits. I am merely showing you the black-and-white road map to a structured closet by way of savvy spending. It is up to you to color it in, using your own chosen palette.

I look forward to sharing the tips that have led me to make better style choices and made fashion even more fun than it already is—the way it's meant to be!

xo ♡ Nicky

Address
Your Inner
Self Before
Getting
Dressed

FIND YOURSELF FIRST

"Be Yourself. Everyone else is already Taken."

OSCAR WILDE

Before leaving for Saks, I gave myself a final inspection in the mirror. I noted the washed-out, folded-over baggy jeans held up by a too-big-for-me belt. Four leather and beaded necklaces lay atop my cropped, cream, long-sleeved sweater in a way that looked casual, but was actually calculated.

I then double-checked the Calvin Klein advertisement taped to my bedroom wall, confirming I was head-to-toe identical to the lithe model. In addition to her outfit, I copied her smoky eye shadow, nude-glossy lipstick and middle-parted, super-straight hair. The model was an up-and-coming Kate Moss. Being a Kate clone was especially important that day because I was going to meet the model I so idolized at her signing in LA, a monumental moment for me at thirteen years old. Obsession was ironically (or was it?) the name of the perfume she would famously pose for.

4 Kate Moss's signature look and style would become catalysts for a fashion movement that extended beyond the catwalk.

She became an obsession to so many of us. What girl or woman didn't crave the kind of confidence to inspire a look and be celebrated for it?

To me at the time, she wasn't "Kate." She represented something that I didn't yet understand but knew I aspired to be. Looking back, I can't believe that I was the only person in line to receive a signed comp card that day. Not long after, Kate rose to muse status. Perhaps subconsciously it was through this experience that I began to understand the power of self-expression through fashion and, because of that, I stopped aspiring to copy the looks of others and started seeking out my own sense of style.

I've come a long way since my copy-Kate days. Over time, I've found my own sense of style and have learned to express my own fashion identity.

As I grew older, my tastes became more refined. I developed an understanding that being stylish is not just about fashion. It's about style. Fashion is what you buy. Style is what you do with it. It isn't merely about collecting; it's about selecting. Identifying your personal signature style and knowing the essential pieces of your wardrobe are key to not only looking the part, but actually having it all, without letting your closet burst at the seams.

Inspiration can be found everywhere. Artists of all kinds rely on inspiration or mood boards to bring together a concept, and I suggest doing the same when conceptualizing your style. A mood board is a collage of anything that appeals to you and, when completed, it becomes a great representation of your tastes. Here's how I relate it to style: If you're drawn to a picture of a pink, frosted, gourmet cupcake or a big, red bowl of cherries, you're probably playfully feminine and would swoon for a sweetheart neckline. If you flip for antique bicycles and pressed flowers, chances are you're boho-chic and into all things vintage-inspired. In addition to places, objects and other things, add to your mood board pictures of people whose look you'd like to emulate.

Fashion is what you buy. **Style** is what you do with it.

How to make your good mood board!

(because a bad mood board sounds miserable)

1. The goods.

Find inspiration from any type of book or magazine—not limited to just fashion, but architectural, entertainment, gardening and more! This is to get an idea not only about your style preference, but about colors and shapes that appeal to you as well.

2. Do it your way!

Tear it out, cut it out perfectly or fold it up. There is no "right" way. There is only your way!

3. Don't think, just do.

This is a fantasy project for you to collage and create your ideal dream board. Don't think about fashion rules. Don't think about your body type. Don't think about anything. It's as simple as feeling connected to something visually, for whatever reason, and spotlighting that connection.

4. Take a step back and take it in.

Look for repeat patterns or common color schemes. What does your board tell you about yourself?

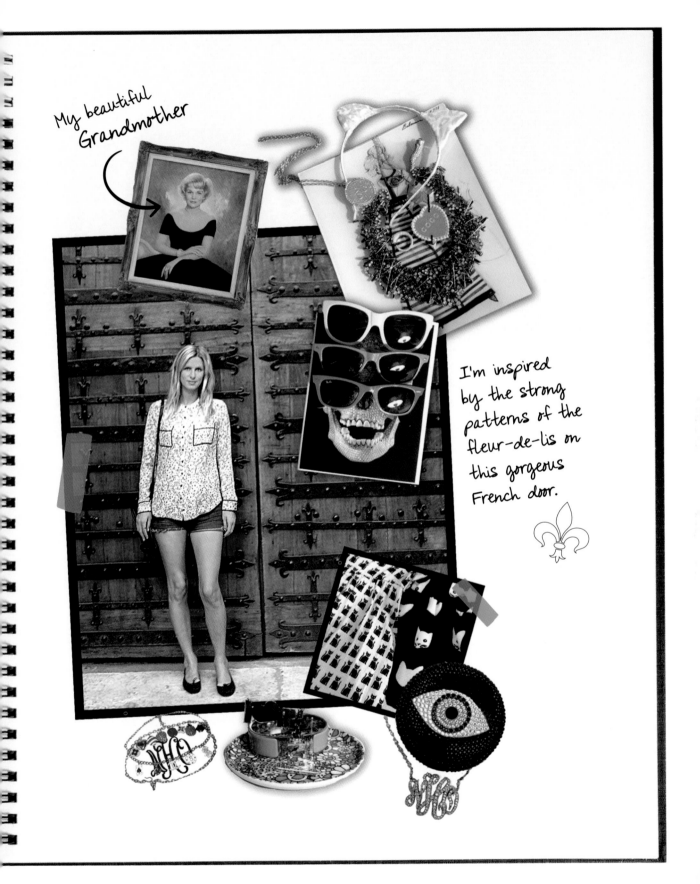

My beautiful Grandmother

I'm inspired by the strong patterns of the fleur-de-lis on this gorgeous French door.

8 Identifying with someone else's style can also help you find your own. Do you resonate with Anne Hathaway's lovely girl-next-door image or Gwen Stefani's edgier everyday rock-star approach? Translating that into fashion terms could mean the difference between a camel-colored swing coat and a boldly patterned cape. While you may admire a certain celeb's style, that doesn't always mean it will translate the same way on you. Knowing what works for and best represents you is the foundation of great personal style.

I am always drawing inspiration from others and learning from their style.

Whether they're fictional characters, friends of mine or icons of the past, I am always drawing inspiration from others and learning from their style. Next time you find yourself admiring someone's look, ask yourself specifically why and figure out how to apply aspects of her look to your own. Here is what I take away from my fashion muses.

Gisele: Minimalist Extraordinaire

When she's not working as a world-famous supermodel, Gisele is just another girl about town. In a *she's so insanely beautiful that the clouds part for her, birds sing to her* kind of way. While it's her job to represent the

haute couture du jour, it is her effortless-looking off-duty street style that has influenced me most. Gisele goes for a streamlined look with straight-leg jeans in classic hues and stays equally as simple on top in a loose-fitting tee or a solid-colored camisole. Her understated statement is what I am after.

She accessorizes at a bare minimum and doesn't wear anything that screams "look at me," but if you look closely, her accessories are perfectly edited and she might wear a loose scarf, a few select gold bangles or a delicate necklace. Girl doesn't mess around with her bags. She usually opts for an oversized hobo or carryall by Balenciaga or YSL. And while not everyone can sport a six- or seven-figure satchel, it's easy enough to emulate the shape and hue at a more reasonable price. I've learned from Gisele not only to simplify my look but also to be loyal to my style. In addition, she schooled me on how to use only earth tones and neutrals for a cool, calm and collected look, much like hers.

Elle Woods:
Legally Amazing

Besides our blond locks and zip codes, Elle and I have much in common. No, I didn't go to Harvard Law, but we both object when it comes to letting the latest trends determine what we choose to wear. We both opt to incorporate what we love into what we wear year-round, whether it's trending or not. While Elle's passion is for all things pink, I am a leopard-print loyalist. And though I appreciate her

10 enthusiasm, unlike Miss Woods, I would never go head to toe in one color or print. Instead, I let a printed tote, scarf or ballet flats stand out from a monochromatic outfit. I also, like Elle, let humor find its way into my wardrobe by way of cute kitten-faced flats or quirky sweaters. I let myself splurge on leopard-print items because it's a lasting style, not a trending one.

♡ For a less expensive way to experiment with my leopard look, pick up a pair of printed tights for less than $15 and see if it puts an extra pounce in your step!

Victoria Beckham:
Taught Me to
Step It Up, Literally

Since her Spice Girl days, Mrs. Beckham has always inspired me. Not only the picture of domestic perfection, she also has created an incredible international fashion empire. Talk about having it all! And, as if that isn't impressive enough, she always looks impossibly chic! By carefully watching this (dare I say) posh powerhouse put anyone who has ever just gotten off a transatlantic flight to shame, I've taken notice of some of VB's distraction tactics and it's upped my overall fashion game.

Remember that one time Victoria was seen running errands on Rodeo Drive in a pair of Swarovski-covered Crocs? You don't? That's because it would never happen! Victoria is always in a pair of amazing heels. Whether she's in leggings, wide-leg trousers, distressed denim or scuba gear—she always gives herself a boost of at least five inches, thereby elevaing her ensemble from casual to casual-chic.

The little boost from the heel makes me feel as if I have risen above average on an otherwise average day. ☺

12 What I admire about her is that she takes height elevation to another level by stepping into those daring heel-less boots. As much as I bow down to her boldness, I know what would and wouldn't work for me: Unlike Victoria, I would look ridiculous in those boots. Even though I wouldn't feel right walking in her shoes, I do feel at home in my platform peep toes and gladiator heels. And if I'm making a quick trip to the bank, veterinarian or coffee shop, the little boost from the heel makes me feel as if I have risen above average on an otherwise average day.

Marilyn Monroe: Cubic Zirconia are also a Girl's Best Friend

Real or Faux? You'll never know!

From clothes and cars to movies and cuisine, I have always loved a classic. Whether they're real gemstones or costume crystals, Marilyn Monroe's penchant for decking her-self out in all things sparkly left a lasting im-pression on many, including myself.

Adding a great piece of jewelry can make the plainest of outfits anything but ordinary. I love

how a glittering statement bib or faux-collar necklace adds an instant oomph to a solid sweater or basic tee. Vintage-inspired cluster earrings are always on trend, as are diamond drops and cocktail rings.

I learned at a young age that sometimes the real thing isn't the right thing to wear, but this lesson came at a scary (okay, it was also kind of hilarious) price. When I was sixteen, a friend invited me to attend the famed Met Costume Institute Gala. At the time, I had no idea what the party was about and how incredible it was to be invited. Still, it was at the Met, so I wanted to wear something fabulous. I went through my mom's closet and found an impressive, canary-yellow, beaded, vintage Valentino skirt, beautiful bustier and Gucci heels. Feeling as if I needed to add a little something to top it off, I turned to Mom's collection. I found a sparkling multitiered teardrop diamond necklace, which really glammed-up my outfit. I headed out the door to the Met feeling great. Once at the party, I received a frantic call from my mother. She was distraught. She explained that a thief had broken in and stolen her prized Chopard necklace and reported that the Waldorf Astoria security was on the case! I touched the baubles around my neck and had to tell her that the teardrop diamonds were somewhat safe with me. Suffice it to say she was not happy. Leave it to me to choose one of the only items that requires security detail.

A great piece of jewelry can make the plainest of outfits anything but ordinary.

Most people don't realize that most of the celebrities they see on red carpets and at events borrow the jewels they are wearing.

14 They are closely followed by the jeweler's security for the night and the pieces go back in their secure safes at the end of the evening. You just never know when something might slip off or be ripped off. When they're out and about, celebrities certainly go faux and I do, too.

Zoe Saldana: Ruler of the Red Carpet

When it comes to bold and beautiful dress choices, Zoe Saldana hits the mark every time. She manages to look like a pristinely wrapped present in interesting silhouettes made of lace, chiffon and satin. Her choices are often ornate and always outside the box, but she always manages to look effortlessly put together due to her minimal hair and makeup. She also keeps the hemline ultra-classy. I find it super-inspiring that she doesn't ever show too much skin. In fact, her high-collar looks are some of my favorites. Rather than give up all the goods, she offers only a peek from a one-shoulder dress or teases in a gown with a high neck but and an ultra-low back.

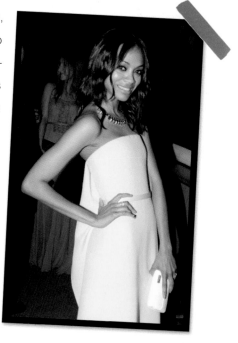

Equally as enviable are her lively color choices. Some of my favorites have been a pair of cropped emerald-green Louis Vuitton trousers she wore to an event in New York and a sunshine-yellow gown that she wore to the Met Gala. Zoe's statements are always a balance of strength and femininity. There's a lesson that reaches beyond fashion!

Jackie Onassis: Keeping It Under Wraps

Invest in pieces with classic lines and timeless appeal.

As far as style icons go, Jackie Onassis tops the charts. Her style exuded an elegance and sophistication that remain unparalleled. Given the ever-changing weather in NYC, Jackie's love for sharp outerwear and need to stay warm in spite of the elements has definitely influenced my own selections. Always impeccably tailored, Jackie Kennedy Onassis wore trench, swing and tweed coats that were nothing short of stunning. I think that people dismiss the importance of tailoring coats to a certain degree because they are worn for a short amount of time and only when in transit. Jackie O proved that tailoring and structure are crucial when it comes to our outerwear. I love looking at pictures of her for inspiration. When it comes to saving versus splurging, I vote to invest in pieces with classic lines and timeless appeal inspired by Jackie O.

Once you have identified the styles that inspire you, the most important step comes next: Make them your own.

Anybody can copy someone else's ensemble and get away with it, but that's not what style is all about. I was anything but authentic when I went to meet Kate Moss

16 dressed just like her. What I should have done then is use her look as an inspiration for my own. Just by changing the color of the sweater from cream to baby blue (my favorite color) and swapping her wood-beaded necklaces for something that was true to my style, I could have put an authentic twist on the entire look.

One of the easiest ways to personalize a look just happens to be my favorite: monogramming. My Goyard bags are gorgeous but incomplete if they don't have my initials. Putting those little letters on your belongings gives them a subtle touch that sets them apart from all others, making them exclusively yours. I monogram everything from robes to sheets to cosmetic bags.

Have fun experimenting and don't be afraid to get creative!

Having a signature item is another way to set yourself apart. Karl Lagerfeld loves his fingerless gloves. For some time, Carrie Bradshaw wasn't without a giant flower on her lapel. What are you known for? What is your thing? Your signature could simply be a color or pattern. Take something that you love and work everything else around it. Try it for one week, or even an entire season. Have fun experimenting and don't be afraid to get creative!

I always find a way to work in a cat of some kind. It's my signature and it makes me smile!

Emulating my first style idol at an early age.

Once you have a strong understanding of your personal style, you are ready to take a step forward in creating your own 3-6-5 system. But first, like any amazing piece of art, you must begin with a blank canvas or a clean slate.

17

I always find a way to work in a cat of some kind. Like my signature perfume, all my friends associate it with me.

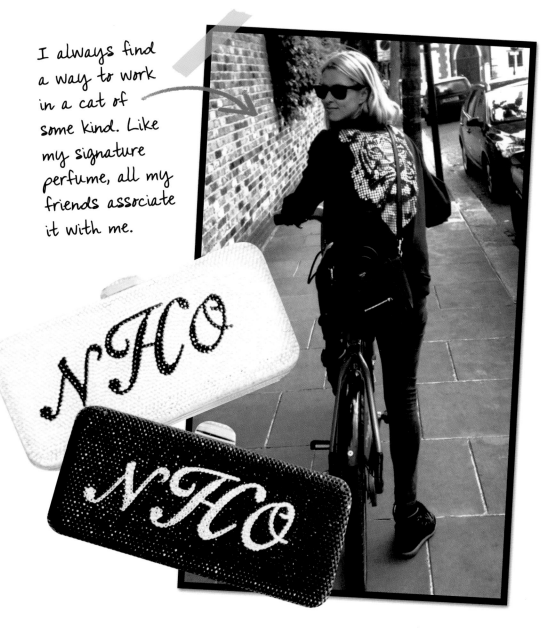

...Because
it Shouldn't
Only Happen
in Spring
(and Flinging
Clothes Across
the Room is
Really Fun)

FLING CLEANING

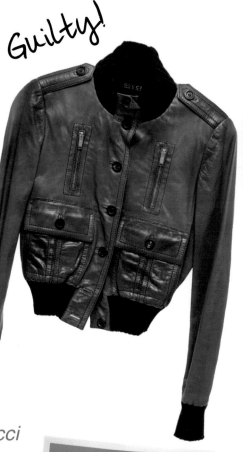

Guilty!

Love it or hate it—it has to be done! Cleaning out your closet can be as cathartic as it is productive. I know how hard it can be to part with the treasures you spent so much time, energy and heart scouring the earth high and low for. Don't worry, friend. You are not alone! I am here to help you let go of that purple leather Gucci jacket that you bought because Madonna wore it to the 2005 European Music Video Awards and it hasn't since left your…Oh, wait, that was me. But you get the idea. I'm here to give you tough love in the name of a tidy closet.

Cleaning out your closet can be cathartic as much as it is productive.

There's nothing less gratifying than seeing countless unworn articles of clothing hanging in your closet, with price tags still on them. ☹

This clearly shows a lack of judgment and a waste of money. When I see too many tagged garments hanging in my closet I go on a "shopping strike." I like to make a rule for myself that I can't buy anything new until I get rid of equal amounts of clothing.

Before you begin to sort what stays and what goes, create four boxes or designated areas and label them as follows: "Keep," "Fling," "Maybe," "Repair." Using the rules below, go through everything in your closet and do so swiftly. Use your instincts and just go-go-go. If you're pondering too long over an item, set it aside to the Maybe section.

22 As far as the fate of that Fling pile, you have options as to where it ends up. There is always the generous option to donate it to a charity or secondhand store. Another idea is to barter. Don't underestimate the power of a trade with your girlfriends. If you have something in your closet that you just know you will never wear again, try to swap with a friend for something of equal value. As they say, "One person's trash is another's treasure." Or as I say, "One woman's fling is another woman's fabulous!" Make sure that it's something you know you are truly ready to part with because no one likes a "taker backer." This could make for an uncomfortable situation with a friend and, if you're reading this book, you clearly are serious about your clothes. If you aren't into the trading game but want to retain some value from your investment, then eBay and local consignment stores are a great option. They are strictly business and nothing personal.

One woman's fling is another woman's fabulous!

Are you keeping it for the right reasons or flinging it for the wrong? Many of us hang onto certain things because they represent a special moment for us. If the item reminds you of something that is moderately important, take a picture of it. Then toss it. If it reminds you of an occasion you find extremely sentimental, you don't need to toss it. You can save it in a clear storage bin. I highly suggest keeping things that don't necessarily add stock value to your closet but have a strong nostalgic value.

One of my favorite fashion memories happened a few years ago, when I went to *Vanity Fair*'s annual Oscar party in Beverly Hills. I wore an off-the-shoulder Gucci minidress that was pale pink with black-and-gray printed flowers. It had a large cowl neck

*So, how to evaluate?
There are a few questions
you need to ask yourself.*

IS IT YOUR SIZE?

We've all said it to ourselves before: "One day, this is going to fit." Okay, first of all, points for optimism. Second, if it doesn't fit you today, it really has no place in your current closet. Put all your one day I'll wake up two sizes smaller *pieces in a box with today's date on it. If you're still not sliding into those too-skinny jeans with ease three months from now—donate them.*

IS IT FLATTERING?

Sure, it zips, snaps or buttons—but does it look good on you? No two bodies are alike and not everyone can wear high-waist, wide-leg pants. It's a cruel, cruel world. (Fling.)

IS IT ME?

Keep referring back to your mood board and inspirations as you refresh your wardrobe. Are the clothes and accessories that remain a true representation of who you are and who you aspire to be?

IS IT RUINED?

If your item has holes, stains, is pilled beyond saving—must I go on?—let it go. Just let it go. If it's something that you love and it's salvageable—get it repaired before allowing it back into the rotation.

24 and I wasn't certain how to wear it exactly. Was it supposed to hang down toward the front or the back, or was it designed to hug my shoulders? I was standing at the bar, chatting with a friend when I got a tap on my shoulder. I turned around and it was Tom Ford. At the time, he was designing for Gucci. He was also my ultimate fashion crush. Ford is so sexy and so are his clothes! He said, "Let me show you how to wear this." He then pulled the fabric over my left shoulder to cover it and slouched the other side, so only one shoulder was peeking out. He smiled and said, "Now it looks perfect." That dress still hangs in my closet today. I would never dream of flinging it.

The dress I'll keep forever, thanks to Tom Ford.

Some things that I hold onto might border on hoarder status, but I choose to keep them anyway. For example, I still have the black Versace dress I wore to the prom. I also still have the custom kimono that was made for me when I went on a work trip to Korea. (I'll definitely never wear it again, but I think it's pretty cool.) I still have my pom-poms and cheerleading outfit from high school as well. Memories are priceless and money can't buy nostalgia. Now, are these specialties sitting front and center in my closet? Of course not. But I know where they are and I like to take them out from time to time just for memory's sake.

An alternative to storing your fashion history is to use the pieces as decorations for your home. I still have my ballet slippers from when I was six and they hang lovingly off a vintage lamp in my

One piece of <u>Pucci</u> that my mother didn't cast away stays with me forever! I treasure this stunning jacket and love that it's in my favorite color. Anything pink gets handed down to Paris and anything blue is all mine.

Your closet isn't the only place to keep collectibles under control. Keep your belongings in check, even on the go.

bedroom. On the same note, if you know you want to have children someday (or you already do), consider hanging onto the items that you know you will want to pass down one day. When I think about the vintage Pucci, Zandra Rhodes and Gucci that my mom *gave away* in the '80s after she had children, I want to scream! As she entered mommyhood she didn't think she would need the fashionable duds and got rid of them. Little did she know that she gave birth to a future clothes monger who would have loved those collectible items. (Cries silent tears.)

Revisit your Maybe box to decide what you really love and what you really need to get rid of. If you truly can't decide, allow it back into your closet, but keep it on a hanger that is facing the opposite direction from the others. If it hasn't been flipped in three months—fling it.

Once you have decided what stays and what goes, the hard part is over! With a completely emptied-out workspace, you can begin to file back in all your belongings.

I invest in flat, velvet-covered hangers. They leave more space for hanging and clothes stay on them better. I also suggest keeping the color of your hangers consistent. They'll make your space seem more orderly and won't distract from the clothes.

No matter what the size of your closet, you have to be able to see everything in it in order to know exactly what you're working with. The same concept goes for shoes—always display them on racks, shelves or in clear shoe boxes; for jewelry—lay it out in drawers or velvet trays; and for sunglasses—line them up where you can see them, as opposed to keeping them in individual cases. The Container Store and Bed Bath & Beyond are the meccas for organizational products.

Even though I have a relatively large closet, stuff still seems to get lost and hidden. I can never find what I am looking for—the same problem one would have in a teeny-tiny closet stuffed to the brim. I like to have a separate clothing rack (these are surprisingly inexpensive and easy to assemble) for all the things that I know I will be wearing in the near future. This includes my latest purchases, which I can't wait to wear, and my good-to-go items, which I usually need to grab and go on short notice. A clothing rack might sound excessive to you but they start at only $20 on Amazon and if space in your bedroom is limited, consider the type that collapses and slides right under a bed.

Before you begin putting items back into your closet, separate them by season. If you're reading this during the summer months, set aside all winter and fall attire. If you aren't able to walk outside right now without a winter coat, there is no reason to keep your sundresses front and center. Arrange what is relevant to you today by function and then by color—work clothes, special occasion, all T-shirts together and so on.

Aim to keep your closet organized like a boutique, with everything sectioned off and lined up, so it's easy to navigate and get dressed.

Handle your accessories in the same fashion. Shoes should be separated by function—all boots together in order of ankle, midcalf, tall and so on. They should also be lined up by color. Organize jewelry by type and lay out your rings, necklaces, bracelets and pins as you'd find them in a boutique, untangled as if they were being presented to a prospective customer. Even if they're costume, even if they were $5 apiece, you need to see what you have and know where it is at a moment's notice.

If you have a large, walk-in closet that could double as a bedroom—first off congratulations; second—you can probably divide the space by seasons. Otherwise, store your off-season attire somewhere out of sight. I suggest purchasing clear, quality containers and hanging wardrobe bags for safe storage. This way, your clothes stay fresh and you have the advantage of seeing what's inside the bags. Besides, there's nothing dashing about digging through cardboard boxes.

And speaking of storage…

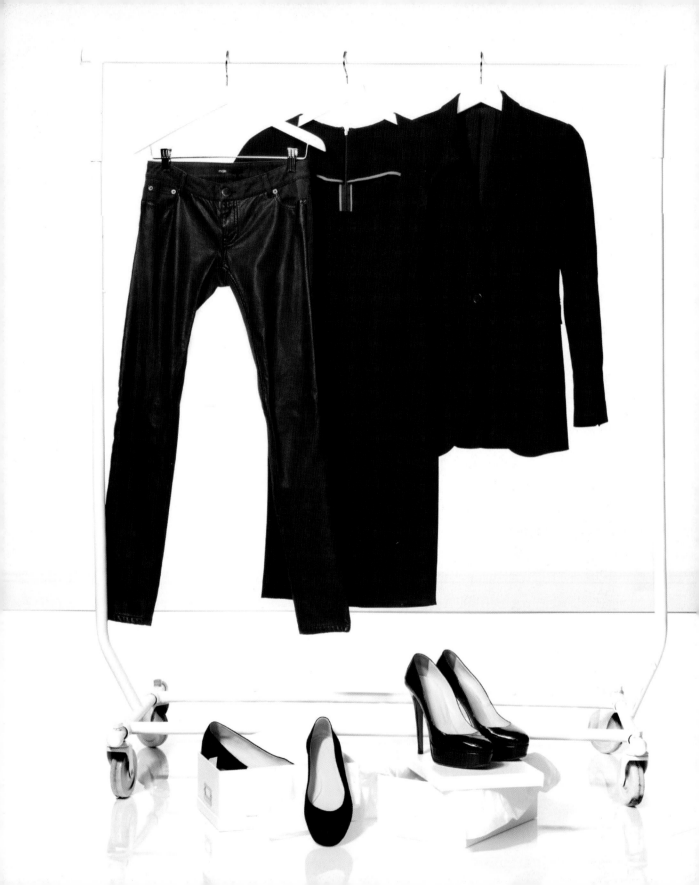

THE BLACK LIST

The Five Items Forever Forbidden to Enter Storage

"One is **Never** Over-dressed or Under-dressed with a Little Black Dress."

KARL LAGERFELD

There are five essentials that stay at the very front of my closet throughout the year, and they are also the first items I am sure to pack when traveling. My fives are always black so they match everything. They are of classic style, appropriate for every season and trend-proof.

Essential #1:
The State-of-Everything Dress

Every style guide will tell you that the LBD, aka the "little black dress," is essential—and, for the most part, I agree. There is

32 much more to this dress than its color. For one, there shouldn't be anything "little" about it. The hem should be at an appropriate length, meaning close proximity to the knee. It shouldn't show any cleavage, either. Long, short or cap sleeves all work for this look, but nothing thinly strapped or strapless. The goal is to look sophisticated and classy, with no flash factor whatsoever. This dress should read as simple, classic and elegant. And, when I say black, I mean pitch-black. This means no sewn-on jewels or embellishments of any kind. Think of it as a blank canvas that you can paint with accessories. It can be toned down for a business casual affair or done up for black tie. My state-of-everything dress by Zac Posen has been a go-to for last-minute weddings (they happen!), dinner with my boyfriend's parents and, most recently, meeting President Obama.

Essential #2:
Perfect Pumps

Whether she has five of fifty pairs at home—every woman has that one reliable set of heels that she knows will go with absolutely everything. When you're racing to go from day to night and you're in a pair of skinny jeans and a loose-knit top, throw on a black blazer with your black heels and you are out the door! For my perfect pumps, I opt for a closed, round toe in patent leather

that's wearable year-round. While basic black might sound boring, don't forget you have fab fabric options, such as velvet, satin and suede. An exception to the all-black-for-basics rule is nude pumps—another basic that should be blacklisted from storage because they go with everything, too. I always pack them on a trip because they are certain to match anything, and I never know what I might buy. For milelong-looking legs, be sure that they match your skin tone. Having black and nude pumps on hand will keep you literally on your toes, ready for whatever last-minute event or quick outfit change comes your way.

Essential #3:
Timeless Blazer

The ultimate go-to item every woman needs in her closet at all times is a classic black blazer. I believe this is the foundation of a fabulous wardrobe and it's therefore investment-worthy. You'll be wearing it again and again, so it's worth spending a bit more for higher quality. But keep this splurge simple so you don't limit its versatility. I prefer a flattering cinched waist. Be sure to refrain from buying anything too fitted. You want to be able to layer it under fabrics of varying thickness throughout the year.

While I splurge on classic black, I save on trending blazers. Chain stores are a great place to find the fun jackets with avant-garde, oversized or embellished shoulders; seasonal fabrics like velvet and linen; and a whole myriad of colors and prints. Not only will these trends come and go, but you will only end up wearing them so many times.

34 The beauty of the black classic is that it creates an instantly polished look. Even paired with cutoffs, a white tee and ballet flats—the most casual of ensembles—that blazer transforms you into an even cooler-looking chick.

The beauty of the black classic is that it creates an instantly polished look.

Essential #4:
Skinny Jeans

My favorite pair of charcoal jeans may as well be called my shadow because they are dark, follow me everywhere and make my legs look super-long. Skinny jeans are flattering, comfortable and so versatile. They have the casual nature of denim, with the added bonus that they can be dressed up and worn to a nice dinner. Not only can they go day to night but they can go girly-girl to tomboy, too. Femme up your skinnies with a flouncy blouse and fun heels or butch them up with motorcycle boots and a beanie. No matter what your mood, these second-skin style-saviors will have your back.

Essential #5:
Classic Flats

Besides a perfect pirouette there isn't anything that I can't do in a pair of ballet flats. Whether it's hopping around the design district, heading to a downtown brunch with the girls or catching a movie with my boyfriend, a chic pair of flats are a definite go-to. Having them in black is an obvious necessity—I suggest investing in a sturdy pair that will last. I always toss a pair into my suitcase and keep another in the trunk of my car, just in case. They're as easy as flip-flops, but much more fabulous-looking.

When shopping for flats, I look for comfort and choose a pair that isn't too round and isn't too pointy. This way you will have a style that can be worn with many outfits for years and years to come.

Your Fashion
Fingerprint

WHAT IS 3-6-5?

"Why Change? Everyone Has His Own Style. When You Have Found It, You Should Stick to It."

AUDREY HEPBURN

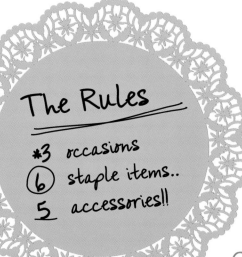

The Rules

*3 occasions
(6) staple items..
5 accessories!!

One day over brunch, my girlfriends and I were discussing each of our approaches to fashion. We shared our perspectives on savvy shopping and personal style. The more we chatted, the more we realized we had a lot to say on the topic, and we were seeing some striking similarities in our approaches to building a wardrobe.

On a napkin, we wrote out our basic mutual style rules and sketched them into a formal structure. We concluded there are only three occasions that we each regularly dress for, varying in description by our lifestyles. We also found that we each had six staple items of clothing and five essential accessories that we needed to complete our wardrobes for each season. We sized up the inked-up napkin and realized we had hit on something

40 of serious style significance. We all agreed that with only these six staple items and five accessories per season, we could be set for an entire year of looks. Why should our closets ever be overflowing with options, if that were the undeniable reality? It was then and there that "3-6-5" was born.

After that historic day, my friends and I lived and shopped with our newly minted minimalist mentality. The results were consistently superb: We all experienced incredible outcomes once we started applying 3-6-5 to our everyday wardrobes. Our closets became much more streamlined, our shopping excursions felt less brutal on our bank accounts, and our time spent getting ready for various events and occasions was significantly trimmed down.

I started telling other friends about the 3-6-5 method, and they reported back with plenty of positive feedback: The system effectively helped them stay out of hoarder territory. I soon realized that everyone could benefit greatly from 3-6-5 and decided that it was my absolute mission to get this guide out there for all the style lovers—like you—who want to shop smarter and look stylish with ease. I have designed this book to assist you in determining your personal style and to suggest fashion choices for every season using this method, no matter how large or small your budget is. I truly believe that when you establish your tastes and discover what works for you, you do not need millions in the bank to look like a million bucks. All it takes to get there is some organization and an open mind.

We had hit on something of serious style significance.

We all experienced incredible outcomes once we started applying 3-6-5 to our everyday wardrobes.

You do not need millions in the bank to look like a million bucks!

3=You

> ## "Create your own style…let it be unique for yourself and yet identifiable for others."
>
> *Anna Wintour*

The number 3 represents your lifestyle and the three most common occasions you dress for. For example, *Clueless* fashion icon Cher Horowitz's 3s would include school, activities and parties. Tess from *Working Girl* would have played up those epic shoulder pads in corporate attire, after-work affairs and business events. Marge Simpson might have switched out her go-to green strapless dress for a daytime errand look, a Sunday church outfit and something special for Homer's work-related soirees. My most common 3s are daytime casual, out on the town and special events, but when I go on a tropical vacation, my 3s change to beach, daytime activities and evening. Your 3s might stay

42 consistent or they might change regularly, depending on your lifestyle. They are meant to assist you in recognizing your wardrobe needs and also to make sure that you are ready for anything that comes your way! When I consider a purchase, I ask myself which 3 scenario that item would fit into and decide if it is something that would truly benefit my wardrobe or if it would just take up space in my closet.

Equally as important to identifying the three dominant occasions you dress for is to stay true to your personal style identity. It's imperative to remember that you're dressing for *you*. Otherwise, you won't feel as comfortable or confident about your choices or yourself. If coral is all the rage this season but you love teal, don't conform just because everyone else is doing it. If something on trend just doesn't suit your style, give it a pass and stick to the classics. Just because it's happening all around you doesn't necessarily mean it has to happen for you.

My sister and I have totally different styles. My mother dressed us like twin dolls for as long as we would allow it, but from the minute we started choosing our own clothes our separate style preferences really emerged. I think the years of being dressed as twins must have gotten to me. I believe with sisters there is always a "pink" sister and a "blue" sister—at least that was definitely the case in my family. Paris is very girly. She loves pink, sparkles and rhinestones—lots of bling. I've always been drawn to more classic, muted colors, almost masculine in tone. Her style icons are Marilyn Monroe and Barbie, while I love the style of Audrey Hepburn and Jackie Kennedy Onassis. The upside of having totally

If something on trend just doesn't suit your style, give it a pass and stick to the classics.

different fashion tastes from your sister is that your favorite pieces
are rarely, if ever, borrowed or "mysteriously disappearing."
Although I have caught my sister on several occasions wearing
some of my things in magazines. But that's okay—it often goes
both ways! I never made a conscious effort to distinguish myself
from Paris through our styles. It just happened. And our style dif-
ferences started at a young age. When my mom decorated our
childhood bedrooms, Paris had the pink Porthault wallpaper and
sheets whereas my room was decorated with blue stars (my mom
said it matched my eyes). It was instilled at such a young age that
blue was my color. To this day I rarely wear pink. Some things just
stick, I guess.

6=The Staple Six

"I like my money right where I can see it... hanging in my closet."

Carrie Bradshaw, Sex and the City

With all the great choices available, it's hard to resist going into a shopping frenzy just before every new season. Many of us blindly enter a store without thinking ahead about a strategy we will use to make decisions about what we will buy. We purchase on impulse and later stand in front of our bursting closets thinking we have nothing to wear. Does this by any chance sound familiar? That was my mode of operation until I figured out how sticking to six staple items every season would help me develop my sense of style and give me guidance when making fashion choices.

As you now know, I always keep a clothing rack outside my closet that holds my most common go-to items. There are always several hangers off to the side, which are in constant rotation—in other words, I have my six staple items in sight every season. It makes

Been rocking the kitten shoes since I could walk. Some things just stick.

getting dressed and packing easy when I know what my tried-and-true go-to items are. I rotate the items out as I wear them, so that I am not wearing the same thing over and over again. For example, in the spring, I will always have a clean tunic on the rack ready to go and, once I wear it, I'll replace it with another one. My go-to 6s are a mix of classic investment pieces that I can use for years and less expensive trend items that will remain in style only temporarily. Keep in mind that my 6s are not going to be another girl's 6s, and they may not be your 6s. You can use mine as a guide to help identify your own individual style and determine what items make up your very own personal list, but each person's staples will definitely be unique to her own style sensibility and her 3s.

I also apply this rule when traveling. Packing used to be such a tedious task because I'd end up throwing everything but the kitchen sink into my suitcase, only to find that I wore just 10 percent of what I packed. By covering your basic pieces and choosing them in complementary colors and patterns, you end up having a cohesive style throughout your trip, an easier time deciding what to wear and, usually, a much lighter load to travel with. (Later in this book, in chapter 9, I'll get into traveling in greater detail!)

People are surprised when they find out I am a seriously conservative shopper. I only invest in pieces with longevity, I go easy on trend items and I love sample sales.

46 An investment item is a long-term staple that will be a part of your wardrobe for years to come. This could be an incredible blazer, a classic handbag, a great pair of nude pumps, and so on. Your investment pieces should be timeless and of high quality.

When it comes to the super-trendy items—think studded jackets and neon accessories—I look to less expensive brands and chain stores and buy items at a price that I know I won't regret later when the item is no longer on trend.

To be spend-savvy not only means knowing when to splurge and when to save, but how to tailor what you already have into what you wish it were. If I love something, I tailor it—even if it is a $45 chain-store dress or a free hand-me-down. We all have pieces in our closet that don't quite fit as they should, so they are either worn without looking as great as they could, or sadly they just stay in the closet.

What a waste—it only makes sense to have them altered so that you can wear pieces to their fullest potential.

I realize that it might be unrealistic to tailor everything you buy, and the most important pieces to tailor are your investment pieces. But there are some great tricks and less expensive alternatives you can use for other pieces, like using tailoring tape to change a hemline, adding an extra button or taking something in by wearing it with a belt. My mother always says when it comes to a hemline on a

I only invest in pieces with longevity, I go easy on trend items and I love sample sales.

Your investment pieces should be timeless and of high quality.

skirt or dress, we should keep those extra few inches of fabric
because while we might want that skirt to hit north of the knee today, in a few years we might prefer something more conservative. And she is usually right. But don't tell her I told you so.

5=Always Essential Accessories

"Before you leave the house, look in the mirror and remove one accessory."

Coco Chanel

48

As a student, I was constantly seeking ways to personalize my look and evolve with the trends while still obeying the school dress code. This wasn't easy, considering the uniform we were required to wear.

My friends and I yearned to experiment with jewelry, colored tights and shoes that changed with the seasons and evolving trends, but our super-strict school rules forbade such things. In fact, wearing nail polish was grounds for detention! (Crazy to think Lady Gaga attended the same school and obeyed these rules, huh?) While I was in school to learn about reading, writing and arithmetic, I also studied *Seventeen* magazine at lunchtime and fantasized about accessorizing my uniform all through gym class.

I could only fit a lip gloss in this teeny bag. Sample size, that is. Not the most practical purchase.

Now that I am all grown up, I have the freedom to diversify my staple outfits by mixing and matching with whatever I fancy. Just as with clothes, there are staple accessories that dominate my wardrobe and make up what I call my 5. My trusty top-five accessories are fashions that are current but not so trendy that they can't be worn next year...or the year after that. By adding a few accessories to an outfit, you can transform, update or set apart your look instantly.

Shoes and bags are definitely my thing. Over the years I have picked up quite the collection—some good investments, others not so good. Take, for example, my teeny-tiny Chanel bag. Its sparkles really drew me in, but its miniature size made it impossible to use, since it gave me no choice but to leave home with nothing more than maybe a lips gloss...in a sample size.

As I have gotten older and wiser, I have come to the conclusion that it is silly to waste a lot of money on the "it bag" that will only

It is silly to waste a lot of money on the "it bag" that will only be "it" for a brief period.

be "it" for a brief period before "it's…not." If you buy the bag of the moment, you'll inevitably see girls with the same bag every time you turn the corner; that does nothing for one's sense of individuality. Now, if I'm drawn to the über-trendy, I will buy something that is similar while still being unique, and find a way to make it my own.

I started designing handbags at seventeen. Most people aren't aware of how demanding the designing process is. You don't simply pick out things that you like and stamp your name on them. It was important to me to learn how the process worked, rather than relying on a team of people to tell me what they knew, so I educated myself about it. I learned so much by diving in! I bought a sewing machine and went to town.

The launch of our Samantha Thavasa handbag collection.

I learned how to add zippers, snaps, Velcro and other types of closures. Sourcing quality fabrics, choosing the perfect lining and understanding manufacturing are just a few pieces of the puzzle. The whole process is very long and time-consuming. It takes about a month to get a sample back from the manufacturer. Then you tweak every single little detail to your liking and send it back to the factory. There are usually a lot of back-and-forth adjustments until you have a perfect prototype. One purse design can take up to three months until it is ready.

Designing jewelry was always a dream of mine, and I was thrilled when it came true in 2010, when I debuted my collection. I am an accessories fanatic and an avid jewelry collector. Costume jewelry is so much fun—and in some ways it's much more fun than real jewelry. You are able to buy more of it, in several colors and styles, and you don't get that anxiety from being scared you are going to lose it or have it stolen. I loved going

50 into the design studio and picking out stones and gems for new collections. It looked like a candy store! Shelves upon shelves full of jars of gemstones in every shape, size and color from all over the world.

I also love meeting with the buyers once a collection is complete and in the stores. They give me feedback regarding what the customers are buying and which pieces are selling best. It is a proud and sometimes surprising moment. Nothing is more rewarding than seeing a stranger on the street carrying or wearing one of your designs! I remember the first time I saw a girl with one of my handbags while I was waiting outside the Ivy valet. It was a very gratifying moment.

GTG

For high school, I attended Convent of the Sacred Heart, a school for girls where uniforms were required year-round. There definitely were times when I wished I could wear anything but the modest pleated skirt and white-collared blouse that every other girl around me was wearing. But I must admit that there was a certain comfort in knowing what to wear on a daily basis. My school uniform would be the dress of the day and building on that became second nature.

As an adult, I seek out staples and think of them much like my school uniform—they are the basics or the foundation of what I wear every day. Maybe this mind-set goes back to my school days and building on that schoolgirl getup. Today, I refer to my basic clothing staples as my GTG, or "good-to-go," outfit.

I believe this classic look best represents me. It is appropriate for most situations and suits both my body and my fashion preferences. Depending on the season and the occasion, I build on and around the otherwise ordinary outfit with accessory items that make it stand out: a subject I became proficient in after spending many years in pleated skirts. Which reminds me—where is my diploma for that? I feel as if I should have at least earned some extra credit. My uniform may have changed, but the principles remain the same.

The best part of knowing your GTG is that it is tried-and-true. You know it fits well, looks chic and is appropriate for most situations. Always have it available and on hand for those days when you are running out the door or just not feeling up to the task of assembling an ensemble. We have all been there! My GTG consists of a black blazer, basic tee, skinny jeans and ballet flats. Simple. Easy. Chic. 1.2.3.

Determining Your Own *6s* and *5s*

In the following chapters, you'll find my own must-haves for each season. My lists are meant to be an example of how I choose staple pieces based on my needs and preferences. In order to create your unique fashion fingerprint and a functioning wardrobe that works best for you, you'll have to build your own lists of essentials. The following quiz will provide and inspire you with your own chic choices.

It's Saturday night and you'd rather be…

A. At a bonfire on the beach with your friends
B. Savoring dinner in a chic, top-rated restaurant
C. A guest at a romantic wedding under a starlit sky
D. VIP at the latest, hottest nightclub opening

Your lips pucker up for…

A. Lip balm
B. Lipstick in natural shades
C. Shiny gloss
D. Bold reds

If you could inherit any celebrity's closet, it would be…

A. Sienna Miller
B. Naomi Campbell
C. Taylor Swift
D. Rihanna

You are most likely to get behind…

A. Ray Bans
B. Aviators
C. Cat-eye sunglasses
D. Oversized sunglasses

You just won a shopping spree
at the store of your choice!
That would be...

A. Your favorite vintage shop
B. Barneys
C. J.Crew
D. Versace

Vacation time!
Where are we going?

A. Bali
B. Paris
C. Hawaii
D. Vegas

If you could be best friends
with one fashion designer,
who would it be?

A. Stella McCartney
B. Tom Ford
C. Tommy Hilfiger
D. Roberto Cavalli

In high school you would be
grouped in which clique?

A. Artists & musicians
B. Mean girls
C. Dance committee & student council
D. My friends were in college

As

Bohemian, hippie-chic, world-inspired—however you wish to call it. You're drawn to eclectic pieces that have a comfortable, relaxed vibe. Look for clothes and accessories that reflect and stay true to your kicked-back style. In my staple 6, a fitted blazer would be my go-to, but a cropped kimono might feel more true to your personal style. A classic strand of pearls probably wouldn't be your first choice, but a dainty gold chain with an interesting coin or charm might be. Swap my go-to little black dress for a softer winter white. There are many brands at price points all across the board that have done boho-chic right. If an ethereal look is what you're after, look to ladies like Drew Barrymore or Florence Welch for inspiration and alternatives to my 6s and 5s.

Bs

Not only can you call out a designer's duds from a mile away, you can name the season, recall which model worked it down the catwalk and who wore it best on Fashion Police. You're a real fashionista through and through. You love labels, lookbooks and follow Fashion Week reports like it's a job. You see clothes as wearable art and you've never met an exaggerated shoulder you couldn't pull off. That said, you meet your matches with standout pieces in bold textures, hues and definitive lines. When I'm seeking out something basic, such as a perfect tee, you should up the ante with a peplum top. Instead of my quirky sweater-dress obsession, you'd likely rather go for a long-sleeved shirtdress with a sharp collar. Not that you need me to tell you that.

MOSTLY Cs

If Charlotte York were your neighbor, you'd be bringing by baskets of fresh-baked banana-nut muffins on a regular basis. Why? For the slight chance you'd score a peek at her immaculate closet, of course. If your ladylike style is best described as soft, feminine and Audrey Hepburn-esque, you are in the right place. You covet designers like Kate Spade and Ralph Lauren who dominate the delicate, sophisticated look. If you are drawn to all things sweet, opt for traditional pieces like cashmere sweaters, ballet flats and classic handbags. When the trends turn to studs and spikes, keep adorning yourself with embellishments such as ribbons and pearls.

MOSTLY Ds

You are bringing sexy back and you are the first one to say it—through your wardrobe, that is. You are sexy, confident and exude fierceness at all times. You aren't afraid of heights and it shows in both your hemline and your heels. In your mind, bodycon dresses can and should go from day to night. Due to your down-for-anything 'tude, you are able to go ballistic with trends. All things neon, cropped, distressed, fringed—none of it intimidates you. Use my list of staples as a simple outline but push them to your further-than-mine, out-there boundaries. For example, while my fall footwear calls for masculine motorcycle boots, you'll feel more like yourself in a heeled bootie or wedged ankle boot. We'll both be working the same trend but looking and feeling like ourselves!

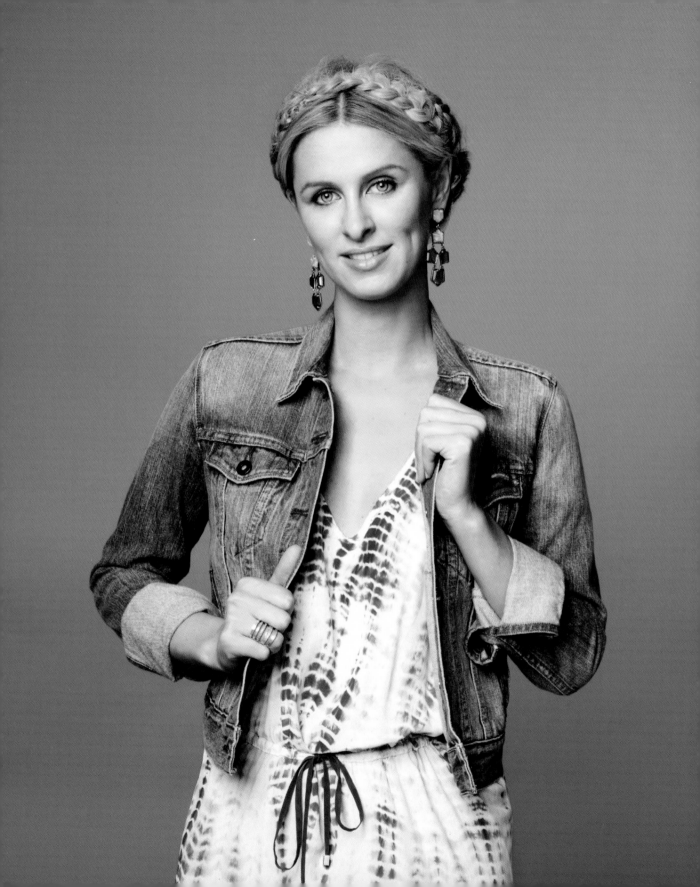

SPRING

6s

Denim Jacket
Flowing Dress
Boho-chic Tunic
The Perfect Tee
Breezy Skirt
Bright & Colorful Jeans

5s

Ballet Flats
Peep-toe Pumps
Colorful Carryall
Cinching Belt
Botanical Baubles

3

Out with the winter wools and heavy patterns—spring has sprung and it's time to celebrate this colorful season by brightening up your wardrobe. Introduce floral, tribal, bohemian and all other whimsical prints in secondary shades to your palette of free-flowing, easy-breezy styles. It's simple to transition your 3s from cold to new!

gtg ♡

My good-to-go outfit for spring is a print tunic dress, paired with a jean jacket and colorful flats.

60 For business attire, simply swap your houndstooth pencil skirt for one with a pastel hue. As long as your lifestyle remains the same, so do your 3s. The only thing that changes is the fabric… and the weather.

6

1: DENIM JACKET

Let's face it: Chances are before most of us girls had our first heartbreak, we were breaking in a blue jean jacket. There aren't many items in our closet today that have remained a staple since the beginning of (our) time and it's a no-brainer as to why the denim jacket has stuck around. Besides being virtually damage-proof and low maintenance, it's also incredibly versatile. Plus, like your best-fitting jeans, a truly worn-in jean jacket becomes a perfect fit to your body and eventually feels as if it were custom made just for you.

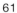

I remember my first jean jacket, which my mother bought me at a store that no longer exists, called Lehr & Black in Beverly Hills. It was a charm-covered jacket with pins and knickknacks all over it. I'm talking baby troll dolls, miniature Barbies, cars, stars, faux candy bars—everything not so strategically glued on. Needless to say, I was obsessed and wore it all the time. As I matured, I learned the lesson of less-is-more and gravitated to a simpler, more traditional look.

Today, I pick up great denim jacket finds at vintage stores or flea markets. It takes a little searching and sifting to find the perfect fit, but it's worth the effort because when you do, that jacket fits like a glove—one that you never want to take off. My vintage Levi's jacket has been a go-to for countless years. It's the ultimate item for layering that looks comfortable and chic over a floral dress, with colored cargo pants or shorts, with boots, flats or sandals. When it cools down, I layer a hoodie under my jean jacket. You almost can't go wrong when it comes to a denim jacket. Except perhaps by pairing it with a similar shade of denim down below. It used to be a major fashion no-no to pair denim on denim at all, but I believe there are exceptions to this rule. A sleek pair of super-dark skinny jeans would look super-cute with a lighter shade of distressed denim on top. I like to pair mine with a brightly colored handbag for a splashy pop in contrast.

Finding the perfect denim topper for you depends entirely on your personal style. The standard classic is universal and complements every person's style. If you're looking for something a bit more standout, the options are endless. Try seeking out something embellished with studs or other hardware, or go for cropped, colored or vintage. Putting your own twist on a classic look is the very definition of style, so go for it!

62 I swap out my leather for my jean jacket in the spring and summer, when it's too hot to wear anything too heavy that doesn't breathe. Both staples essentially serve the same purpose: to give you a stylish, effortlessly cool look.

2: FLOWING DRESS

As the temps rise, our bundled layers fortunately fall. After a chilly season of covering up, there's nothing more exciting than putting on a femme frock and feeling the sun on your skin again. The days become longer when we spring forward, encouraging us to stay outside—often keeping us out and about hours after the sun goes down. For this reason, I look for dresses that can conveniently go from day to night, business to bar, day to date, or date to date—depending on your speed. No judgments here! Light and airy, flowy spring dress styles include peasant, gypsy, baby doll, knitted—there are so many great choices out there that the hardest part will probably be deciding which one to wear.

Diane von Furstenberg created the wrap dress in 1974 and by 1976 more than 1 million savvy ladies had snapped them up right away. Every season since, DVF has reintroduced the wrap in varying shades and patterns, with other designers following suit. Paris and I both wanted to wear the same DVF wrap to a *Vanity Fair* cocktail party once and rather than playing rock, scissors, paper for who got to

wear it, we decided it would be more fun to be twins. Win-Win!
Whether you're a curvy bombshell or a petite pixie, the shape is flattering to all body types. It's one of the few items in fashion that says sharp and sexy at the same time.

While universally flattering, the same rules apply to a wrap dress that do to all others. Don't pick a color that isn't going to flatter your skin tone or a print that won't do any favors for your shape. Splurge only on long-lasting hues that will stay on trend for a good amount of time and save on prints that are trendy in the moment but irrelevant next year or possibly even next season.

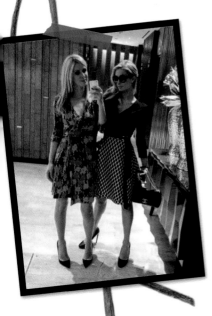

3: BOHO-CHIC TUNIC

Tunics are a perfect springtime staple for so many reasons. Besides coming in unique, fun prints and being available at all price points, they are chic and as easy-breezy a clothing item as the vibe they give off. Tunics are an inexpensive way to "throw on and go" and still look impeccable. If you are constantly travel-ing, or even getting dressed at the gym, a cotton or poly tunic is perfect for packing because it doesn't wrinkle. One more bonus? No dry cleaning necessary.

I find myself choosing the same peasant-style, bohemian tunics that are in my closet over and over again. The ones that work best for me are by Missoni and Tolani. To mix them up a bit, sometimes I wear them loose and other times I cinch them with a belt for a different look. Love the versatility.

Speaking of versatility, tunics are amazing because they are a fashion "do" in so many different situations. They make a great swimsuit cover-up, top or dress. If it's a warm spring day, tunics

64 work with jean shorts, and if it's cooler, they look super-cute with jeans or tights. While tunics work for everybody, they are not designed for every body. Know what works best for your figure before you stock up. A boldly patterned or ruffled tunic would add delicious curves to a boyish frame but it could look something like a circus tent on an already bootylicious babe. If you're looking to conceal your midsection, go for soft, light and forgiving fabrics that cinch around your hips. If you're pear-shaped, choose a hemline that reaches the smallest part of your upper leg—usually a few inches above the knee. It's an easy way to look instantly leaner! Add your own accessories, like chandelier earrings, bangles and colored sunglasses, and you're good to go—anywhere.

4: THE PERFECT TEE

Doesn't it seem strange that we are forever on the hunt for the perfect T-shirt? It's the most simple, basic item in American fashion and yet finding the right one is nothing short of a miracle.

It really bothers me when designers just stop making something without any warning. I come to depend on and fall in love with a product and then—poof! It just vanishes without even a second of coverage on CNN! I've learned the hard way. It's happened with jeans, bras and, most commonly, makeup. Calvin Klein used to make my favorite lace bra. It was almost like a sports bra—super-comfy, but it looked sexy when I'd wear it under tanks with the lace slightly peeking out. I sadly misplaced mine, so naturally

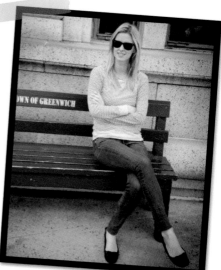

Love this top from Target.

I went straight to a department store to buy another one. This is when—are you sitting down?—I found out they no longer carried that style and it was now "discontinued." (Cue the violins.)

Now, when I find something that I love, I don't just buy one. I buy it in bulk! This rule most certainly applies to the perfect tee—also known as the chupacabra of clothes. Alexander Wang has my heart for creating the perfect jersey shirt and Club Monaco is a close second. So, what makes a T-shirt perfect? For me, it's seamless, opaque, feels well-worn and is made of a soft blend, usually cotton, rayon, linen and silk. Above all else, the perfect T-shirt must be well made. Since they are not just worn casually anymore, today's tees need to be of high quality to maintain their crisp, fresh appeal. In general, tops should fit your frame without being skintight. Back flab caused by an ill-fitting bra should be avoided at all costs. A flattering shirt will drape over your curves nicely without showing everything along the way.

Once you've found the perfect T-shirt for you, stock up in staple blacks and whites. Then scoop it up in solid colors and stripes, so you can have an option to layer a few of them if that style works for you.

Just don't forget to buy it in bulk. Don't let my disappointment become your reality.

66 *5: BREEZY SKIRT*

As much as I love body-skimming pencil skirts, there is something playful about a looser-fitting skirt that moves with you, especially for spring. I happen to be a fan of the long floor sweepers, which I think are so cute with a gladiator heel or wedges. Throw a denim jacket on top and I feel like myself. When stepping it up for a less casual look, I love the high-low look inspired by the opening sequence from *Sex and the City,* when Carrie wore the tutu and white tank (remember?). Ever since, you see so many ladies pairing a flashy embellished skirt with a basic tee or top—and I'm one of them!

It's much simpler to pull off this super-stylish look than you might imagine. The number-one rule is there can only be one fabulous focal point in the entire ensemble. Whether you've chosen a glittering mini, a voluminous satin floor sweeper or a decorated peplum skirt, everything else needs to be toned down to the basics. Your tee or tank top, flats or heels, accessories, hair and makeup must be minimal and simple. Trust me, you'll look très chic!

6: BRIGHT & COLORFUL JEANS

I was born in the '80s, so naturally neon was a big part of my childhood, especially where fashion was concerned. I even had a neon-themed birthday party once! As a tween, I rocked neon-colored jeans, leggings and even bike shorts (remember when those were cool?). From then until my mid-twenties, I stuck to standard blue denim.

I didn't encounter colored jeans again until my mid-twenties, when they came back in style. Isn't it funny how history always repeats itself—in fashion, too? Today, jeans represent just about every part of the ROYGBIV spectrum, taking decorative denim to a whole new level. Bright and exciting colors and prints seem to just make the day happier. Am I right?

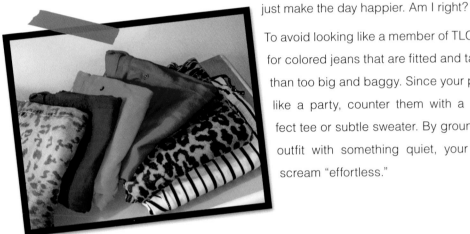

To avoid looking like a member of TLC, opt only for colored jeans that are fitted and taut, rather than too big and baggy. Since your pants look like a party, counter them with a solid perfect tee or subtle sweater. By grounding your outfit with something quiet, your style will scream "effortless."

5

1: BALLET FLATS

My love affair with the ballet flat started at a very young age. As I've mentioned, I went to a school where the wearing of uniforms was strictly enforced. This meant collared shirts and itchy wool

68 skirts (never to be more than two inches above the knee or you were given detention! And, yes, I got in trouble for violating that regulation quite often) worn with chunky, hefty saddle shoes. The minute that three o'clock bell rang and we were dismissed, I would make a beeline for my locker to get out of those horrendous, heavy shoes. They were so uncomfortable. I would change into my ballet out-fit for my after-school class immediately. The moment I slipped into my slippers I felt an instant delight.

My love affair with the ballet flat started at a very young age.

While so much has changed in my life, the one thing that hasn't is the need for a pair of pretty, comfortable staple shoes that can be worn every day. I find it sweetly comforting that these are still a go-to. There are tons of ballet flats featuring vibrant colors, funky prints and cool fabrics, which make for a great focal point in an otherwise monochromatic outfit. Conversely, choose a more muted pair if you have lots of prints and patterns going on.

While I love my nude and black ballet flats, you can often spot me (pun intended) in my leopard-print pairs. Those are classics that I love to wear year after year.

2: PEEP-TOE PUMPS

Peep-toe pumps are a great go-to heel. That subtle front cutout, which exposes your toes, amps up an everyday pump, giving it the teeniest hint of sex appeal without being over the top. With different price points, colors, fabrics and heel heights, the options are end-less. Peep toes work with pants, skirts or dresses—love that!

The most important thing to keep in mind when buying peep toes? Make sure you can walk in them! We've all been there. You find the perfect-looking pair of shoes that are, well, not totally

comfortable, but you justify the purchase, take them home and try to wear them out for the first time. The next thing you know, you're sitting solo watching purses while your friends are having a twerk-off on the dance floor. Save your soles and be realistic. If they don't feel good in the store, leave 'em there. There are tons of perfect and comfy peep toes out there for you!

My Christian Louboutin Yoyo pumps are my absolute faves. I have had them for years and no matter when I put them on, they instantly make me feel giddy. The sleek heels have signature lines and a classic structure, so the sexy shape is and always will be in style. Since the shape of the shoe makes it investment-worthy, I allow myself to splurge on exciting colors and fun embellishments. Louboutin isn't the only one to get it right. Other brands of peeps that make my heart palpitate include Dolce Vita and Steve Madden, who each put their own twist on the Yoyo. I am all for reaching new heights, although, once again, if you look like a tightrope walker walking in your shoes, the heel is likely too high for you. Strut much sexier in a less staggering heel. Remember, only those in the circus have a safety net to catch them. The rest of us will only get caught...on video.

3: COLORFUL CARRYALL

I had a Balenciaga bag before anyone really knew what they were. I picked one up in Paris in the summer of '99. I was drawn to it because I liked that its shape was practical and simple. The soft, lightweight leather and edgy hardware made it a perfect

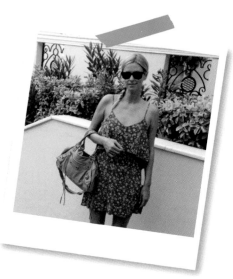

70 everyday bag. When I came back that summer, none of my girlfriends took notice. However, the following summer, they—and practically every other fashion lover—all had one slung over their shoulders. Interestingly enough, Nicolas Ghesquière (the designer of Balenciaga) said the now-famous motorcycle bag almost never saw the light of day. He created a prototype, which the company dismissed as "too lightweight and too lacking in structure." He convinced them to let him produce the purse for his runway show so the models had something to carry while they walked. The models where so enamored with the bag—particularly Kate Moss—that he knew he must include them in the permanent collection. Now they exist in practically every color under the sun.

If you're in the market for a new carryall, there are a couple of important things to keep in mind. First, the shape—and how it works with yours. When you try it on and look in the mirror, does your potential new bag enhance your silhouette? Second, one of the reasons why I love my Balenciagas is that the leather is super-soft, supple, durable and light. Even after I've placed my many must-haves for the day inside the bag, it doesn't weigh a zillion pounds. Quality leather doesn't have to be heavy, and lugging a bag around that feels like an all-day bicep workout is just not fun. I also appreciate the zippered pockets so I can keep my wallet tucked safely away. Lastly, Balenciaga's hardware and tassels appeal to my rocker-chic-meets-classic sense of style. While those are "me," what's my reco? Find a carryall with embellishments that are 100 percent "you."

4: CINCHING BELT

One of the best function-serving fashion accessories is the shaping, slimming and style-saving cinching belt. While I love loose tunics and dresses, sometimes I feel a little too go-with-the-flow and seek a look that shows my true shape. By adding a thick belt that fits snuggly across the smallest part of your midsection, you can transform the entire look. You can cinch pretty much anything, including sweaters.

On my last vacation, I lived in a sheer Missoni caftan that served as a cover-up on the beach all day and then went with me into the night when I added a slip dress, a belt and heels.

5: BOTANICAL BAUBLES

After the long stretch of snowy days and colder temps, seeing one budding flower is all it takes for me to start thinking about springtime accessories. Trendy yet classic, there are so many great spring options for rings, bracelets, necklaces, earrings, barrettes, pins and brooches. The result? You can have a blast with botanical baubles and mix them up for different looks, depending on your outfit and occasion. My grandmother left me a sapphire bracelet and Paris a ruby one that we like to bring out every spring. Each has beautiful flowers delicately placed around the bracelet. As with clothes, I love to mix and match the high and low with jewelry. Different metals, gemstones, beads and floral designs provide infinite options across all price points. I love the $5 finds from street vendors and estate sales.

One bauble caution: Don't get drunk on flower power and wear everything at once. Too much of a good thing is…not a good thing.

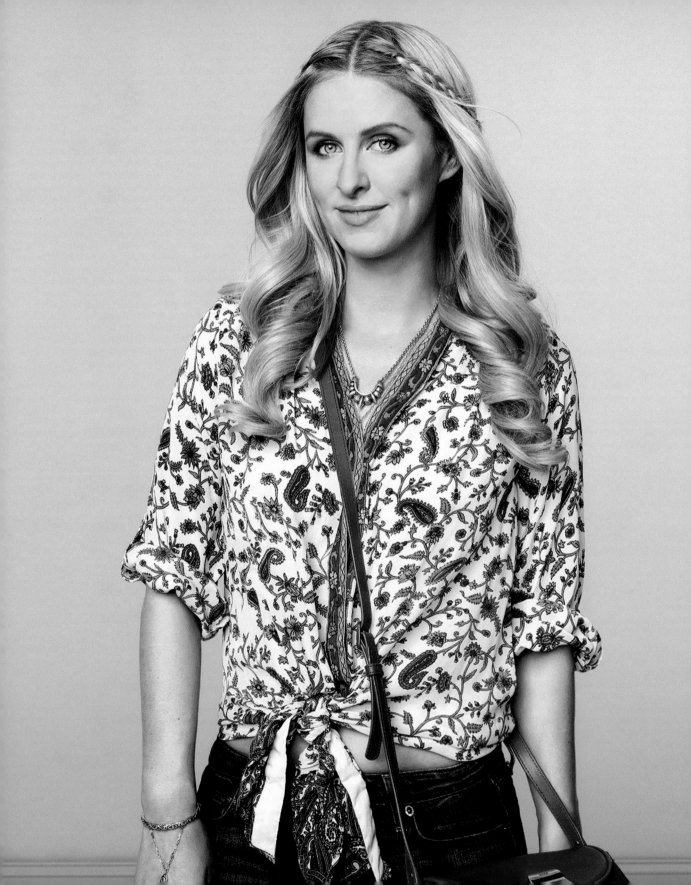

SUMMER

6s
Day-to-Date Sundress
Cropped Vest
Romper
Miniskirt
Cutoff Shorts
Bikini

5s
Gladiators
Natural Wedges
Hobo Bag
Fun-in-the-Sunglasses
Classic Fedora

3

Summer fashion is all about looking just as hot as the weather while keeping cool. I look for fabrics that don't cling and pieces that go beyond the basics, such as swapping an interesting vest for a simple tank top. For your summer looks, consider pieces that can be dressed up or down with a few simple additions so you can seamlessly soak up the beautiful weather from day to night without having to stop for an outfit change, no matter what your 3s are.

gtg

Cutoffs, loose-fitting tank, gladiator sandals, hobo and sunnies.

76 Summer tips include the $30 item I can't live without, my deal with sunglasses and why I may be the only girl in LA to have never had a spray tan.

1: DAY-TO-DATE SUNDRESS

For so many of us, summer means having a good time. The sun is sizzling and so are you! When the weather heats up, so does my schedule. Invitations for events from sunrise to sunset are all planned specifically to take advantage of the warmer temps, and that is why it is so important to have a day-to-date summer dress that takes us to and from.

Last summer, I was loving the Miami sun so much I stayed at a pool party just a few minutes too late. Without a second to spare, I boarded a flight to LA wearing the high-low cut maxi I'd worn to the party. When I landed, I received a text from my cousin that the

girls were getting together for dinner. Instead of heading home to change, I dug into my carry-on. Off went my ballet flats and on went my nude wedges. I swapped my cozy flying sweater for a jean jacket, my tote for a clutch and—voilà! That dress took me from a daytime pool party through travel to dinner and even a late-night drink.

The maxi dress is a definite summer staple. It is easy to convert from afternoon coffee with the girls to a sunset cocktail date and there are endless options for colors and prints. Form-fitting on the top and with just the right amount of looseness in the full-skirted bottom, maxi dresses are subtly alluring, gorgeous and low-maintenance. In selecting a maxi, it is important to find one that flatters your body type. The key to the maxi dress is minimum exposure. The top should fit snuggly to your chest so that it supports and offers adequate coverage to your girls. You don't want to be constantly checking, tucking and tugging to be sure that you're not falling out of your frock. Top it off with a billowing floppy hat or a sleek bun to look like a glam sun goddess.

2: CROPPED VEST

Since we were little, the obvious staple item for summer has been the basic tank top. No longer kids, we need a grown-up look that takes us to a higher grade of glamour. For me, a cropped vest is a simple and stylish way to add a light layer and a heavy dose of fashion to your look. Throwing on an embellished vest is a fun way to give those basic tanks a bohemian feel or add a little edge to a floral or white sundress.

78 Cropped vests come in so many different cuts, designs and styles. Fringed, denim, kimono silk, studded—there is a cropped vest for everyone. I love my leather motorcycle vest from Topshop. I've picked up some great ones from H&M, too.

3: ROMPER

Summer season means one major thing to me: music festivals. My cousin Brooke and I have been going to Coachella every summer since I was fifteen. Back then, it wasn't this festival with major corporate sponsors and media coverage; it was just a casual concert we loved to attend. We would buy a $45 ticket from a scalper outside, get in and rock out. Now, if you're lucky enough to score a weekend pass, it can cost you upwards of $600. But I digress… The vibe of Coachella lends itself to a certain playlist, as it does to a certain wardrobe. And, given the hot and sticky daytime sun, I always opt for outfits with minimal fabric and maximum comfort. My Coachella weekend wardrobe could also apply to any outdoor event. Rompers are my go-to because I feel feminine but not too girly-girl. Plus, I can sit comfortably on the grassy knoll and cruise around with confidence knowing they won't fly up or off, as a dress might, especially when we're dancing like nobody's watching.

I always go strapless in the sun, so I don't end up with tan lines. One last style essential—I never forget my sunblock, and you shouldn't, either.

My sister and I finding creative ways to keep cool at Coachella.

4: MINISKIRT

When looking for minimal material when the temps are maximized, I reach for my must-have miniskirt. I call American Apparel miniskirts my secret weapon. At under $30, the price is right and I own one in just about every color available. (You already know how I feel about buying in bulk when I find something I love.) I bring the basic colors with me as backup options when I travel because they go with everything, are washable and durable, and fit like a glove. Need more reasons why I love these miniskirts so much? They are short but not offensively so, they don't wrinkle, they're always on trend, they work well with pretty much any top, and transition perfectly from day to night. Hiking up an already short skirt is a no-no. The only cheap thing about a mini should be the price.

My secret weapon miniskirt came to my defense in a serious fashion bind a few years ago. Chanel sent me a short, black, sheer chiffon dress to wear to an event and the high slits went way too high for me. In a last-minute pinch, I used the mini as a slip and it blended in perfectly.

5: CUTOFF SHORTS

Maybe it's the California girl in me that can't let them go, but nothing screams summer to me more than a pair of done-at-home denim shorts. When the boyfriend-jean craze swept the nation a few years ago, I finally made use of the old baggy jeans that were crumbled up in the back of my closet. I cut them midthigh and rolled them up to give them a more polished, cuffed look. They turned out to be a super-cute look with a loose button-up.

I recently transformed my favorite ripped Jet thrasher jeans, which had a few too many holes in the knees, into shorts. I kneeled down and ripped what once were a few strategically placed tears into a huge hole that left half my leg coming out. I was disappointed because I loved the fit of those jeans, but they made for perfect cutoff shorts for the summer.

For warm evenings out, I still stick to shorts, usually black satin or leather. I think it's totally acceptable to wear them with a modest heel if they are an appropriate length, meaning no cheeks peeking out from the bottom.

6: BIKINI

French engineer Louis Réard invented the itty-bitty bikini in 1946. He named the bathing suit after Bikini Atoll, an atomic bomb test site in the Pacific. Over the years, bikinis and reactions to them have definitely lived up to their namesake location.

I'm a big fan of string bikinis. I like that you can adjust the bottoms, preventing love handles. I always make sure to tie them on tightly because I've definitely had them almost fall off in rough waves. If you're shy when it comes to showing your midsection but still want

to wear a two-piece, a fringed top will provide a little something so you don't feel so exposed.

Before you head to the store or hit the shore in your new bikini, there are definitely important pointers to keep in mind. Remember that finding a two-piece with the right cut for your body type is key. Please don't make the mistake of insisting on buying something just because you love the print, color or brand. If it is not the right fit for you, it will garner the wrong kind of attention. I am also a fan of one-pieces with a scooped back. Pin-up-inspired pieces are incredibly sexy on hourglass figures. Channel your inner Marilyn and hit the waves!

Once you have the best bikini for your bod, leave the bling at home. It will eliminate the risk of losing a fave earring in the water, getting a funky tan line courtesy of your baubles or looking like you're just trying way too hard. What you should be concentrating on is soaking up the fun and the sun. If you feel completely naked without any type of accessory, I recommend a bangle bracelet, but that's pretty much it.

As for your feet—flats are the only way to go. Wearing high heels with a bikini is a definite no-no! They are beyond offensive on the beach, by the pool and at a car wash. There is no excuse! And if you get stuck in the sand, I will not be able to help you. You see, people will be posting numerous pictures of your wardrobe malfunction on Instagram and I just can't allow myself to be an accomplice to a fashion crime of that degree of crazy.

5

1: GLADIATORS

I love, love, love a pair of gladiators. I'm willing to give Russell Crowe credit here because after seeing *Gladiator* in 2000, if feels like this style of footwear has come back from ancient times, cemented its place in modern life and will continue to be a fashion favorite well into the future.

If they are not too cagey and costume-like, gladiators can be a focal point of a funky ensemble or enhance a boho-chic outfit. The flat style is perfect with shorts and pants for daytime, while a heeled version can instantly increase the glam factor of a skirt, dress or any nighttime ensemble. There is an edgy toughness to gladiators that is decidedly unfeminine and, to me, that's what makes them so chic. Just about every shoe designer has a variety of gladiators, so the only tricky part will be narrowing your options down to the ones you want (or, should I say, need) the most.

2: NATURAL WEDGES

A few years ago, a friend of mine got married at a lovely church in Italy and I wore a pair of beautiful five-inch encrusted Christian Louboutin slingbacks. Sound sexy? It wasn't. I was absolutely miserable. The grounds were paved with cobblestones, which made it impossible to walk anywhere without a high risk of eating the floor. A pair of wedges would have saved me in this circumstance. The beauty of wearing a long dress is getting to wear super-supportive foot-wear. I love having an excuse to wear a wedge under a long dress because no one can see them. Style and comfort are always the ultimate goals.

Style and comfort are always the ultimate goals.

Natural—meaning nude, khaki, camel or beige—wedges provide a stylish yet subtle complement to just about any summer ensemble. Classic and understated, they feel fresh and new every warm season.

This is a must-have summer shoe for me because of the look and versatility. Nude wedges can be worn with cutoff shorts to a super-casual brunch or to an elegant cocktail party with a breezy summer dress. Also, since most summer entertaining happens outside, there is no need to worry about a stiletto getting stuck in the party host's backyard.

3: HOBO BAG

A hobo bag is a great summer carryall that easily transitions from day to night. With its long shoulder strap, crescent shape and large, slouchy, unstructured interior, a hobo is a versatile bag

84 that can change along with your activities each day. Hobos are known for being roomy enough to hold all your daily (and evening) essentials. You can bring everything along with you in one smart swoop. By removing the shoulder strap, your crescent hobo morphs into a clutch, completing your evening look.

I adore my Devi Kroell hobo for summer because it is a light gold hue, which adds an elegant accent to my day and evening outfits, and it can hold all my must-haves without looking like an overstuffed bag that is about to burst. These are great details to consider when seeking out your own.

When you are going to an event in an unfamiliar place, check out the venue online first. This way, you know what you're getting into as far as atmosphere and elements, such as sand, grass, cobblestone, stairs and so on. Having the right type of shoe is key in these circumstances. Nothing ruins a good night out like bad-fitting footwear.

4: FUN-IN-THE-SUNGLASSES

As the sun gets stronger, there actually is one body part that most people start covering up—their eyes. In their purest form, sunglasses are protective shields designed to prevent damage to the eyes from bright lights or the sun. As long as we are supposed to wear them, it's all the more reason to make them a fun and fabulous accessory.

I love a good pair of sunglasses. The perfect pair of sunglasses protects the area around your eyes (the thinnest most sensitive part of your skin) from getting wrinkles, you don't have to wear makeup when hiding under a pair, and they're good for blocking eye contact and avoiding people if you want to fly under the radar.

All that said, they also accentuate and enhance your look. There are so many people and even movie characters that are closely associated with their trademark sunglasses. Jacqueline Kennedy Onassis, Rachel Zoe and even Tom Cruise's "Maverick" in *Top Gun* are all known for their distinctive shades.

I own many pairs of sunglasses. I scoop them up in all my favorite styles (classic black, aviator, cat eyes) and go back and forth between saving and splurging, depending on the trend and brand. For some reason it always seems that I lose only the most expensive ones. And I hate buying the same thing twice. It feels like such a waste! I have lost many sunglasses to the sea when swimming, getting crushed by waves, jet-skiing… I can't imagine what fashion-

86 able treasures line the bottom of the ocean. I've bought the Tom Ford "Whitney" sunglasses three times and lost them three times! It clearly was not meant to be.

If I spot an interesting pair of glasses being sold by a street vendor for a few dollars in a color I wouldn't typically buy, I don't mind giving those a try, too. Experimenting on the cheap and having fun with trendy items can be a great way to expand your sense of style without any bankbook buzz kill.

I can't imagine what fashionable treasures line the bottom of the ocean.

5: CLASSIC FEDORA

If you thought it was a menswear item that we ladies borrowed from the boys, you are not alone. But here's a little fashion background—the word *fedora* comes from the title of a play called *Fédora*. It was written for Sarah Bernhardt in the 1800s and she played the heroine, Princess Fédora, who wore the hat in the play. Since its debut, the fedora became a fashion staple due to its practicality, crushability and low-maintenance felt.

A classic fedora is a great way to provide added protection from the sun with a splash of great fashion. If finding a terrific topper sounds confusing, fret not. You simply need to stick to the same guidelines you use for selecting every other element in your closet. First, choose a flattering color that enhances your skin tone. Next, are you selecting the right size? I am a big fan of asking for help when I am in uncharted territory.

To paraphrase Goldilocks, it shouldn't be too big or too small. It should feel just right. The right hat for you should also frame your face beautifully, just like a great pair of sunglasses. You may also want to consider adding a grosgrain ribbon, a distinctive broach or a pin for a personal touch.

I bought my favorite cap from House of Ill Repute in New York years ago and still wear it all the time. I fell so in love with the brand that I commissioned them to do a few hats for my Nicholai fashion show during 2008 Fashion Week at New York's Bryant Park.

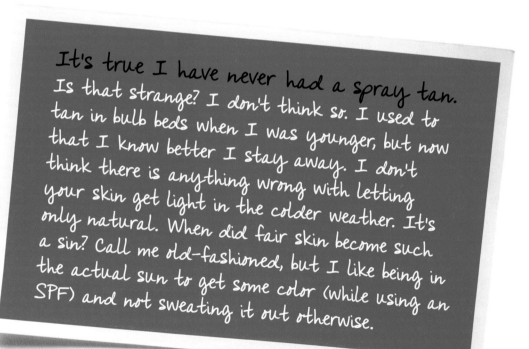

It's true I have never had a spray tan. Is that strange? I don't think so. I used to tan in bulb beds when I was younger, but now that I know better I stay away. I don't think there is anything wrong with letting your skin get light in the colder weather. It's only natural. When did fair skin become such a sin? Call me old-fashioned, but I like being in the actual sun to get some color (while using an SPF) and not sweating it out otherwise.

FALL

6s

Collared Shirt
Classic Jacket
Sweater Dress
Dark-wash Skinny Jeans
Leather Everything
Giving Sweater

5s

Boy Boots
Loafers
Scarves
Crossbody Bag
Large Envelope Clutch

3

Fall is a season that begs for cuddling by the fire.

In my opinion, fall has it all. Think cozy boyfriend sweaters and loose layers in warm colors like olive, burgundy and gray. No matter what your 3s may be, fall is a season that begs for cuddling by the fire after dancing in the rain.

gtg ☺

Dark jeans, booties, sweet sweater, crossbody tote and scarf.

6

1: COLLARED SHIRT

A crisp, clean button-down makes an outfit look impeccably tailored and put together. It's simple, subtle and what was once known solely as a menswear staple has become a must-have in women's closets, too. A collared shirt comes in different cuts to flatter a wide spectrum of body types. It can have short, three-quarter-length or long sleeves and is available in an array of different colors and patterns. The versatile styling options make this shirt anything but basic—you can wear one tucked neatly into a pair of skinny jeans, underneath a blazer or dressed up a bit with cool cuffs links. Many of them are wrinkle-free, too! American Apparel, Ralph Lauren, Brooks Brothers, and J.Crew—the list of collared-shirt shopping prospects is endless.

I consider collared shirts a cool, classic wardrobe staple. Over the years, it's been fun to see how celebrities and characters on the silver screen interpret this staple with their own sense of style. At the 2011 Academy Awards, the fashion world was abuzz about Sharon Stone's completely chic look—she wore a lilac Vera Wang evening skirt with a white button-down from the Gap.

Great pieces don't have to come at a high price.

And in one of my favorite movies, *Pretty Woman*'s Vivian Ward rocked Edward Lewis's white button-down and his world when she paired the same plain white with a miniskirt for a Rodeo Drive shopping excursion. These two button down game changers inspired me to wear my own version to a red carpet benefit back in 2008. I paired it with a black bandage mini, accessorized with a studded Burberry clutch. My crisp white button-down shirt + classic accessories = an outfit that's still relevant nearly five years later. Don't you just adore fashion arithmetic?

2: CLASSIC JACKET

Bring on the goose bumps! I have always had an obsession with coats and jackets. In fact, my home in Los Angeles had a closet that was designated strictly for them. Ironically, with the gorgeous LA weather that rarely falls below 75 degrees, my fabulous finds generally never got any airtime, but now that I'm living in New York, I get plenty of opportunities to bring my outerwear outside.

Investing in a good trench coat is essential. If you can splurge on this practical staple, you can't go wrong with a camel-colored Burberry. If you're working with a tighter budget, look for a similar cut, color and quality fabric, then have it tailored to your measurements. Investing in a bit of tailoring will pay off every time

94 you put on your coat. It is such a flattering shape, like a dress that will keep you warm and dry.

Great pieces don't have to come at a high price. I'm a big fan of army jackets. All the designers these days seem to include them in their collections. I purchased a terrific one years ago at the Salvation Army. They have a great selection that is inexpensive and authentic.

3: SWEATER DRESS

The perfect solution to staying warm without getting lost in layers is to simplify with a one-piece look. With a sweater dress, you get the best of both worlds. I love wearing a thick dress with tights because I might look like a fab girl on the go, but I feel as comfortable as I would snuggling in pajamas at home.

Like any other staple, you can wear this piece casually with boy boots or dress it up with tights and a chunky heel.

There are high and low options for this trend. It's safe to invest in anything classic and made of quality fabric, as I mentioned before, but I also like to have fun with prints that are in at the moment. Sweater dresses can feel pretty binding and if you would rather divert attention away from your midsection, do so with a standout scarf

or faux-fur vest. If it's a loose-fitting dress that you seem to be lost in, find your curves with a great belt.

4: DARK-WASH SKINNY JEANS

Slim-fit pants, aka skinny jeans, have been around for years, and they don't seem to be going anywhere anytime soon. I think that's a good thing! My skinny jeans are super-comfortable and feel like a second layer of skin, and that's why they are a must-have for me. Skinnies are incredibly versatile and look great with sweaters, blazers and long-sleeved tees. Personally, I prefer a dark wash and I opt for a pair with a bit of Lycra, which allows the jeans to flatter my curves, rather than flattening them. If I'm pinched for time, any top works and then I slip into flats or tuck them into boots—my dark-wash skinny jeans never steer me wrong.

As an alternative, I also love riding pants. They are super-chic paired with boots and a sweater. I always check out the local equestrian store in my neighborhood to see what they've got. You'd be surprised what great finds are in there.

My other fall fave worth mentioning is a pair of corduroys. Cords provide a good alternative to jeans when you feel like mixing it up. I love the vintage-y vibe they give off and they keep you warm, too.

5: LEATHER EVERYTHING

One of the best pieces I ever designed was a leather schoolgirl-style skirt for my collection, Nicholai. I find myself wearing it every season, either bare-legged or with tights when it gets

96 chillier. Since it's pleated leather, you can play with the style to be either naughty or nice. For the HBO *Girls* premiere, I took the sweet route and paired it with a feminine, tucked-in, white button-down and black Brian Atwood ankle-strap heels. For a nice but relaxed night out, I wear it with a sweater and booties.

I also love leather pants. My favorites are my Alice + Olivia leather leggings. I was given them as a gift from the designer, Stacey Bendet, a good friend of mine whom I've known since high school. Way back when, she was selling her famous pants out of her small Upper East Side apartment. They can really be worn on any occasion. I'm always wearing my leather pants with a top and blazer. Sometimes, I will throw on a T-shirt and a pair of Converse sneakers for a more casual look. I recently wore them to a luncheon with a Chanel tweed blazer and it gave my look a combination of classic meets contemporary cool (and eliminated any potential stuffiness, too).

If the 1820 nursery rhyme was right, and girls really are made of "sugar and spice, and every-thing nice," then consider the leather jacket your spice. This tough-lady topper instantly ups your cool points when paired with pretty much anything. Balance the look by keeping things sweet underneath, literally and figuratively speaking. I'm not opposed to going faux when it comes to leather. In fact, there are some amazing vegan designers out there, including one of my favorites, Stella McCartney. Zara and H&M also make great faux leather pants — you can't tell the difference!

Fall, for me, is all about apple cider, pumpkin spice lattes and Thanksgiving feasts.

6: GIVING SWEATER

Fall, for me, is all about apple cider, pumpkin spice lattes and Thanksgiving feasts. I am one of those people who is always cold, so I am sure to throw a sweater in my purse just in case I get chilly. Something about being cold and knowing the holidays are approaching makes me want to indulge...and I don't mean that in a shopping way. I don't know about you, but I feel like it starts off with some innocent snacking on gingerbread and too soon ends up with a muffin top. This would be why I love long, loose and forgiving sweaters, or what I like to call giving sweaters. Oversized cardigans, boyfriend sweaters and roomy crewnecks all leave enough room to hide your full appetite when you've stuffed yourself like a turkey.

For the sake of keeping things authentic, I believe that boyfriend sweaters shouldn't necessarily be purchased, but borrowed (and often never returned). I went to visit my boyfriend in London and checked the weather before I packed. The forecast was pretty warm, so I packed a bunch of light clothes and a leather jacket. Lo and behold, I arrived and the weather took a turn for the *freezing*. Thankfully, my boyfriend shares my love for all things warm and cozy, so I ended up wearing all his sweaters and coats for the entire trip. In fact, I loved them so much that I never gave them back. Oops! His Rag & Bone cashmere sweater is still in my closet.

5

1: BOY BOOTS

I call any boot with a masculine edge boy boots: This includes army, motorcycle-style and horseback-riding boots. Of course, I realize that girls do all those activities, too, I'm just saying that nothing about these boots politely whispers tea party. A distressed, worn-in look exudes tough-chic to me, and the lower heel height makes it easy to run to wherever I might need to be while being dressed up just enough.

Ironically, while I love motorcycle boots, jeans, jackets and shoes, I do not like motorcycles. I think they are scary and dangerous! But while I don't like motorcycles, I love the don't-mess-with-me attitude and image of motorcycle-inspired style. Moto boots are extremely comfortable and look great with a dress (long or short) and jeans.

I bought my favorite pair at Madewell a few years ago, and I wear them all the time. Oddly, my boyfriend told me they are his favorite pair of shoes that I own. Random, right? Out of all the pretty shoes I own, he likes the masculine biker boot?

If a specific type of boy boot doesn't appeal to you, consider a low-rise bootie with a low-to-flat heel. This basic look can be paired with anything, goes with all styles and is widely available at every price point.

I'm just not a fan of rain boots. Practical? Yes. Fashionable? Not so much. So, my reco is to absolutely have a pair, but go subtle and don't draw extra attention to them. No prints or colors here—save that for your cute rain jacket or the ballet flats you slip on once you've arrived somewhere nice and dry. Rubber boots are ugly enough—why draw attention to them?

2: LOAFERS

Sole sisters, it's time to read carefully. Loafers are a wonderful combination of a flat and a slipper. Comfortable and chic, loafers are a great shoe style that works for a variety of occasions. First things first. Need to walk to work but don't want to sport sneakers on the way? Loafers are the solution. This style has exploded in popularity yet it remains a classic design that has been and will be around for decades. Thus, if you want to rock an edgy ensemble, opt for a more muted pair to balance things out. Conversely, there are whimsical designs, spikes and eccentric prints to choose from that will reflect your personal style and are perfect for spicing up a more conservative outfit. Go ahead and get personal! You can also have yours monogrammed. They work with skirts, dresses, leather pants, jeans, cords—the list goes on and on—providing unlimited wardrobe options to go with your fabulous feet.

100 For a classic look, I am a loyal fan of Tod's driving shoes. As of late, I have a slight obsession with my Charlotte Olympia kitty loafers. And so does my kitten, Mac!

3: SCARVES

Scarves are an incredibly easy way to instantly amp up, polish and tie together your ensemble. What's more, you don't need to break the bank on a beautiful one since they can be found all over. I find mine everywhere from boutiques to chain stores to outdoor markets, so you can decide whether you're in the market to purchase an investment piece or experiment with inexpensive, of-the-moment ones.

Adding a pop of color to a monochromatic out-fit with a wrap is not only easy and stylish, but also functional. I often grab a scarf or two when I'm running out the door, and I think it's mostly because I can hear my mom's voice in my head from when I was running out the door as a kid: "Cover your neck!"

4: CROSSBODY BAG

I owned my first messenger-style bag in high school. It was black nylon Prada and I used it as my school bag. There is something so liberating about being hands-free and not holding a handbag. You can sift through clothing racks, put cold hands in your pockets or hold hands with your honey, all while balancing a coffee, texting and doing anything else you fancy. Not to mention you

can carry anything you might need throughout the day without looking like you're moving crosstown on foot. That's why a crossbody is a perfect everyday solution. Plus, if you need to peel off a few layers, a scarf, hat and light sweater can be tucked away in the bag until they're needed again. Functional and fashionable, a crossbody bag ensures that we can bring all our must-haves and might-want-to-haves along, for whatever the day might bring.

This convenient bag comes in a variety of different colors, prints and durable materials—consider nylon, canvas and leather, as they are just a few of the options if you're in the market for one. Which bag is best for you depends on its purpose. Your corporate boss might not appreciate a multicolored, Pucci-inspired crossbody as much as he or she would a natural-toned leather or canvas type, but your friends sure will!

5: LARGE ENVELOPE CLUTCH

Sleek and chic, a large envelope clutch is the perfect item for just about every occasion. It can add a great pop of color to a monochromatic look or complete an ensemble because it's that perfect goes-with-it-all accent. I don't like when women wear big purses in the evening—it looks informal and disproportionate—but the clutch is ideal for a night out. What's more, unlike a teeny-tiny clutch, the envelope clutch has room for more than one mint, a lip gloss, a $20 bill and the key to your apartment.

If you're looking for a large envelope clutch to complement your look, there are a few options to consider. Retro, classic, funky, elegant, sparkly, patent leather, silk, jacquard, sequined…okay, there are more than a few! I believe every girl should own at least a few in neutral colors.

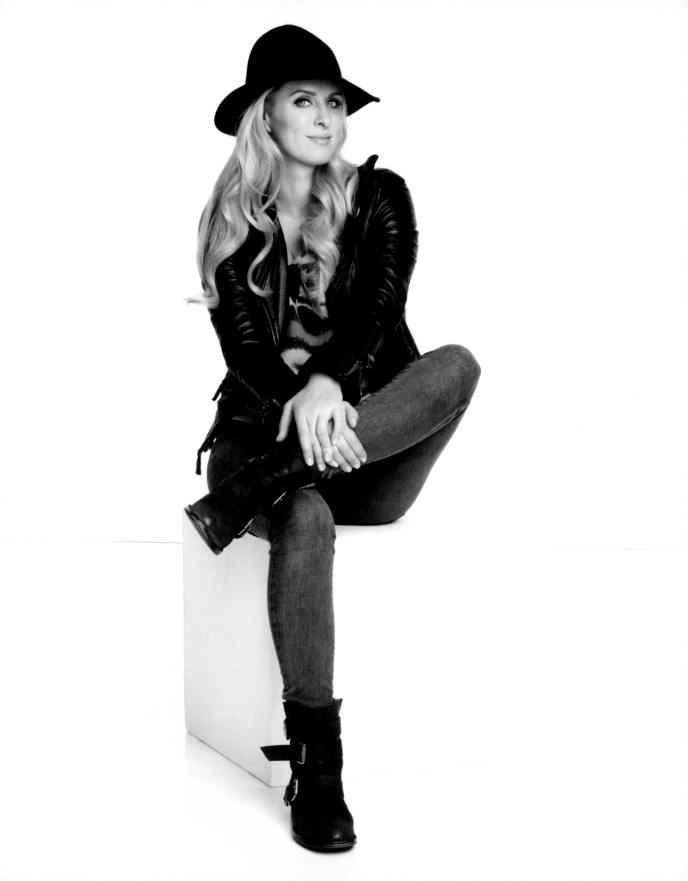

WINTER

6s

Statement Jacket or Coat
Shift Dress
Ornamental Cocktail Dress
Cashmere Sweater
High-collar Blouse
Fleece-lined Leggings

5s

Closed-toe Pumps
Booties
Tights
Sparkly Box Clutch
Bib Necklace

3

Be your
own
ornament
and shine!

Winter is the ultimate season for the girly-girl within. It's the one month where everyone should list festive parties as one of their 3s. Plus, a chance to dress like a present and get away with it. Why not? Wear cashmere sweaters with embellished bows, lace tops with ribbon-tie collars and shoes decked in sparkles and bling. This is the season to be your own ornament and shine!

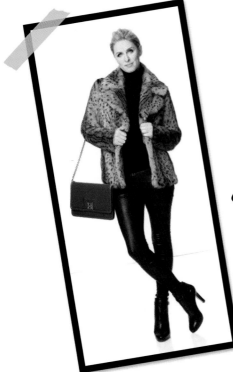

gtg

Leggings with booties underneath a luscious, cozy and chic coat.

106

1: STATEMENT JACKET OR COAT

There is nothing like watching snowflakes fall gently from the sky, noticing the first time you see your breath or walking beneath twinkling lights everywhere you go to get you in the holiday spirit. Per-haps the festive and decorative winter months inspire me to keep the celebra-tions going by wearing luxe statement coats with an extra flash factor. These pieces are heavier and richer than what we wore last season. Functionally, they are long enough to cover your bottom and made of quality materials that keep you toasty. When I'm feeling femme, I turn to something ornamental, such as my royal blue Stella McCartney swing coat. If you prefer things on the masculine side, I love a puffy black North Face or bomber jacket. Both are savvy

> *Self-expression is just one of the elements that makes fashion so fabulous.*

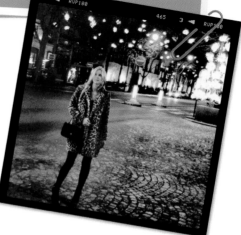

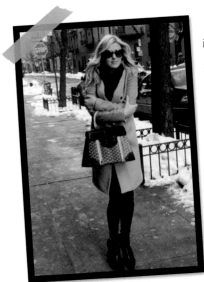

investments for both of your style sides and will keep you warm year after year in that crisp (and chilly!) winter air.

I love my faux-fur jacket from Club Monaco. It feels plush and soft, and looks just as fantastic. I do not wear real fur; I think it's cruel and hideous. To quote Karl Lagerfeld, "Fake is not chic…but fake fur is." Now that's a quote and a coat to live by.

If you don't already have one and are looking around, a beautiful coat can be your personal calling card, a confidence-booster that makes you feel unstoppable every time you put it on. Regardless of the price, the cut, the texture, the color, the length and the style, this coat should feel luxurious and special to you. After all, self-expression is just one of the elements that makes fashion so fabulous, don't you think?

2: SHIFT DRESS

In a season that's full of traditions, wearing a sophisticated throwback such as the shift provides a perfect blend of looking classy and feeling sensational. In fact, I feel very Holly Golightly from *Breakfast at Tiffany's* when wearing one. The shape is appropriate for all types of social gatherings and I keep it young and fresh by choosing one in fun hues with like accessories. With its forgiving cut, infinite array of colors, fabrics and price points, a shift is a fashion must-have for all. Sure, this dress style can be worn year-round, but the ones in my closet that I love are perfect for winter because they dazzle in richly colored jewel tones and scream to be taken out on the town.

108 A friend of mine who works in fashion was hosting a party for the brand French Connection in Hollywood. She sent me over a garment bag of clothes to choose from. I chose a cute sequin leopard shift dress (you know I love a good animal print!). I get out of the car and walk to the red carpet to pose for the press photographers. As the flashes are going off, I look over to my left and see a blond girl with her back to me being interviewed wearing the exact same dress! The girl turns around, and it's my friend, actress Jaime King. We immediately burst into laughter and end up both posing together on the red carpet in the exact same dress. Thank goodness we styled it a little differently. I belted the dress with my thick, black Balenciaga belt and wore my hair down with loose curls. Jaime had her hair pulled back. Jaime and I weren't bothered by this little fashion "crime"—we thought it was kinda funny.

3: ORNAMENTAL COCKTAIL DRESS

A gem-colored gown adorned with just the right amount of bling, though not too much, is a great way to make a festive statement. My mother used to dress up us girls like little presents around the holidays. There was a whole lot of velvet, tulle and frilliness happening on the dresses she'd put us in. I'd definitely say that those outfits wore us! As cute as those over-the-top outfits were then, anyone old enough to count to ten should tone it down—a lot.

Getting all dolled up to look like a holiday gift definitely carried over into my adulthood; it's just a bit quieter these days. I still love a ribbon bow, but instead of wearing a massive one atop my

head, I go for a soft sweater that features an embellished bow around the collar.

One of my favorite holiday looks is my silver-sequined tuxedo dress. It is double-breasted, inspired by a menswear jacket. Even though I wouldn't normally go for head-to-toe sparkle, this piece is an exception because it doesn't have the shape of a frilly dress. I've actually worn it as a coat, too, in an effort to maximize its out-of-the-closet time because I love it so much. It is so versatile and classic. A definite long-term keeper. It was more of a splurge, but I've worn it so many times and in so many ways over the years that it has been worth the investment.

4: CASHMERE SWEATER

Is there anyone who doesn't like being swathed in cashmere? It's a gorgeous fabric, and department stores, chain stores and boutiques everywhere offer an array of options to make you feel warm and fuzzy—on the inside and out. Cashmere is a great investment piece because it never seems to go out of style, so if there is a style you like, and it is offered in a wide variety of colors or goes on sale, know that you can't go wrong.

I have a lot of chunky robe-like cashmere sweaters that I practically live in during the winter. I love the soft, long ones. If I'm headed out to a meeting and I don't want to look like I'm in a bathrobe, I replace the matching belt with one of my cool vintage ones to cinch the waist.

There are many, many ways to wear a cashmere sweater. Pair it with jeans, dressier pants or skirts, or add a pin or a scarf to accessorize—it's one sweater with about a zillion potential looks!

110 You already know that I am addicted to blazers, so it should be no surprise that I love to put a cashmere sweater on under a blazer. Then I can change it up on the bottom with skinny jeans or a skirt. No matter what look you're going for, with a cashmere sweater as part of the ensemble, the overall effect is bound to be fabulous.

5: HIGH-COLLAR BLOUSE

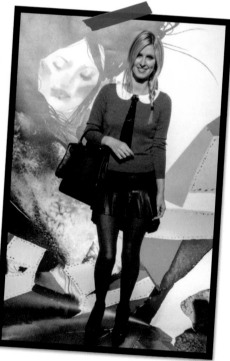

An up-to-there top done in lace or satin exudes femininity. This antique-y look is a beautiful way to play up your ladylike side. It is individual and alluring, without exposing too much skin.

I particularly love the lace-collar blouses because they are so pretty and each one is different from the next. Kind of like a snowflake in the form of a shirt, you know? I also adore tops that have an exaggerated bow at the nape of the neck and a little ruffling works for me, too. My one caution would be to avoid high-collar pieces when there is too much fabric or too many ruffles—it sort of makes you look like a clown or court jester. If you're going to go for the high-collar look, adhere to the less-is-more rule on top and keep it simple with everything else.

In July 2012, I went to Paris with my parents for Fashion Week. I was attending the Valentino Haute Couture show. When I checked into the Plaza Athénée, there was a garment bag from the designer with a few options to wear to the show. I was delighted to find a black beaded jumpsuit, a long pink gown and a short pink dress. I opted

Some things never go out of style! Still love a classy Peter Pan collar.

for the beaded jumpsuit for the show and the pink rose dress for the after party. As my mother and I were getting dressed, I got a frantic call from the Valentino PR office: "Do not wear the jumpsuit! Maria [Grazia-Chiuri] is wearing it to the show. We cannot have you both in the same outfit. It will be a disaster!" Maria designs for Valentino alongside Pierpaolo Piccioli. Thank goodness I came to Paris prepared with options. I like to wear the designer of the show I'm going to out of respect—besides I would feel weird showing up in another designer's clothes.

By chance, I had another Valentino dress I had recently purchased at the Beverly Hills Valentino boutique. I ended up wearing a black leather Valentino dress with lace bodice and a high-neck pearl Peter Pan collar. Crisis averted!

6: FLEECE-LINED LEGGINGS

Super-cute and ultra-warm, these footless tights with a fleece lining have become a winter wardrobe favorite of mine. The frigid air can be brutal, and these luxe leggings provide an extra layer of warmth, whether you're wearing them alone or under a pair of jeans. Because they're lined with a soft layer of fleece, you'd think they would be bulky, but they're not. These snuggly warmth savers are easy to find online in different colors, patterns and price points.

I love lounging around the house in them and wearing them under jeans for extra warmth while I run around the city. They are

112 amazingly cozy and for those days when I don't feel like getting completely out of my PJs, I can secretly feel like I didn't! I may have lived in my snowflake-patterned ones for an entire season one year, but I'm not going to confirm that.

Ladies, wearing leggings as pants is a highly debatable topic, and for good reason. While some people say that "leggings are not pants," I respectfully disagree. I think when worn correctly they make for a great staple item. I tend to wear them with longer tops that cover my behind. You don't want to have your rear end on full display. Cover it up with a long top, like a tunic or an oversized blouse. And leggings should not be the centerpiece of an outfit. Wear something impressive on top to distract from the fact that you are wearing leggings.

If the shoe fits!

Be mindful that after numerous wearings and washes, leggings tend to get a bit see-through, so don't be that girl walking down the street in see-through pants. Once you hit the sunlight, things start to show. Sadly, I speak from experience. I was walking down the street with my father one day and he turned to me and said, "You know your leggings are totally see-through, right?" Embarrassing!

1: CLOSED-TOE PUMPS

When it comes to the holidays, I am all about sparkly, glittery accessories. As soon as the department stores start playing "Jingle Bell Rock," two things come to mind. One, wasn't Halloween just a few days ago? And two, time to bring out my most festive footwear. When I saw Carrie Bradshaw place the blue satin "Something New" pumps on the shiny shelves of her dream closet in the *Sex and the City* movie, I fell in love right then and there in the theater. Just as Carrie ran back to retrieve them and later wore them to her wedding, I ran straight from the theater to Bergdorf Goodman and there they were. I tried them on and said, "I do." I had to have them in my life. Bergdorf's also carried the shoe in neutral colors like black and white, which clearly would have been the more practical choice. But I just had to have the blue Carrie shoe. While I can't promise that they'll make it to my future wedding, they have accompanied me to many a holiday party. Till death do we part.

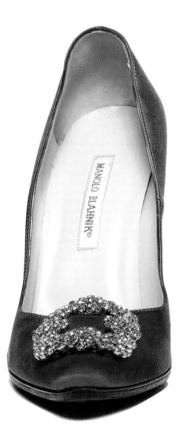

114 ## *2: BOOTIES*

An ankle-length boot, aka a bootie, is a like a gorgeous hybrid of all my favorite styles of shoes. While it's not a boy boot or a knee-high boot, it shares the same edgy rock-and-roll effect, but with a femme flair and daintier presence. A stiletto bootie can be flirty and on the sexier side, and just the right shoe choice to wear to a ladies' luncheon or cocktail hour.

With regular boots, I keep it simple because they are a big statement on their own due to their size. With shorter boots, you are able to get funky and be loud. I have a cutie bootie collection that includes leopard print, studded, cowboy and so on.

3: TIGHTS

Hands down, the one item that can either enhance an outfit or ruin it completely is tights. I tend to stick with black because they're slimming and they go with every-thing, but every so often I like pairing a bright red, purple or green pair under a dress or skirt. I may even on occa-sion wear a pair of fishnets, which are en vogue—if worn tastefully, that is. One color that you won't find me wearing is white. That look reminds me too much of Eloise from the Plaza and I've never seen it done right, so I just stay away. Some women spend just as much on a pair of tights as they would on a sweater—typically, I don't, because there's no true way to salvage them after they get a run or a hole. I love the Hue brand because for less than $15 I can stock up on staples and trending items without spending too much.

For specialty tights, it's okay to splurge a little. I bought an amazing pair of Giorgio Armani tights with black crystal bows on the ankle that were more than my usual spend for tights, but worth it.

I store my tights in a drawer alongside my socks. Every few months, I check for holes by putting my arm in the legs and if they have a run, I toss them. So many girls try to save their tights with clear nail polish, but that's why it's wiser not to splurge. Save yourself the fright of getting a run while you're running around and replace the pair.

To avoid "muffin top" when wearing tights, cut the sides of the waistband. Even the **skinniest girls** have this problem when they wear skintight dresses. Tights got their name for a reason. Problem solved!

116 *4: SPARKLY BOX CLUTCH*

My parents bought me a bejeweled, monogrammed initial clutch from Judith Leiber for my birthday one year. It first caught my eye when I saw Sarah Jessica Parker with one. (By now you know I love a monogrammed anything and *SATC*, so clearly this was the perfect gift.) When it doesn't accompany me to black-tie events, I have it on display in my living room as a decoration.

Sparkly box clutches are like tiny works of art. They are the perfect pairing for a holiday soiree. For inspiration, look to Jimmy Choo, Lulu Guinness and, of course, Judith Leiber. When you find one that you fancy, be sure it has a secure clasp and crystals. If your clutch doesn't close or it begins to lose its luster after only a few wears, it isn't worth any type of investment. Although it is meant to be small, it should be roomy enough to carry the essentials. One year, I splurged—and I mean *splurged*—on a teeny-tiny Chanel bag. It's about the size of my hand and adorned with silver sequins all over—a real feast for the eyes. The only problem is that it can barely fit a peanut inside, let alone my keys, license and a lipstick. That was a splurge I definitely should have saved, since the baby bag has yet to see the light of day—or stars of night, for that matter.

5: BIB NECKLACE

The most beautiful way to bling out a top belongs to the bib. These tiered necklaces are works of art on their own and they dress up any plain tee, sweater, dress or strapless top. They used to mostly be natural gem–colored, but now they come in fun hues like neon and are made of offbeat materials like safety pins. Add one to your state-of-everything black dress to make the ordinary extraordinary.

No need to splurge here. I recently bought a Peter Pan collar made of pearls for less than $20 that I can wear with long- and short- sleeved tees year-round.

Ready for
Takeoff

TRA-VEL

3-6-5

"Beauty of Style, Harmony, Grace and Good Rhythm Depend on Simplicity."

PLATO

Traveling is an enormous part of my life. I am constantly in go-go-go mode, whether it's attending Fashion Week in Paris, business meetings in L.A., snowboarding in Aspen or catching a music festival in Palm Springs. This chapter will show you how to pack like a pro jet-setter and be ready for anything using the 3-6-5 system.

I've sat next to the celebrities who arrive at the airport dressed to the nines in strappy sandals and leather pants looking refreshed in a way that seems impossible after a five-plus-hour flight. Allow me to let you in on a little secret: It is impossible. The moment the plane takes off, so does their perfect outfit, and makeup, too. They change into something less fashionable and more comfortable and settle in for the ride.

122 Then as soon as we begin our descent—voilà! They change again, put on their faces and are transformed back to their super-fabulous selves. A lot of work if you ask me!

While my destinations are always different, what I take with me on a flight always remains the same. Let's start at check-in. I like to wear an easy-on and easy-off pair of shoes that require socks. Do you really want to walk through security barefoot? Gross. A pair of flats, ankle boots or booties that slide on with ease or require a short zip are best. I advise against anything laced or complex. Be sure they're a pair you plan on wearing during your trip to avoid overpacking on shoes.

Velour sweatsuits are admittedly part of my single-girl-at-home attire, but there are chicer things to wear when jetting to and fro. Start with a loose-fitting, breathable top, but nothing too low-cut that could shift midnap and lead to an embarrassing wardrobe malfunction. Accompany that with a pair of fleece-lined leggings, which are perfect for chilly evening flights, or with the equally comfortable silk trousers, jeggings or, if you can pull them off (and be honest with yourself, because not everyone can), harem pants. I like to bring a chunky, knitted cardigan or wrap that can double as a blanket. This also works with a wide cashmere scarf or an oversized sweater. Although most domestic flights provide a blanket and long international ones an eye mask and socks, I choose to carry my own set.

easyJet

Passenger
HILTON/NICHOLAI

From
Ibiza

To
Malpensa(Term2)

Flight Date Seq No.
EZY2692 03AUG 18

Boarding Group
SB

Be sure to drink extra water throughout the travel day.

Embarrassing truth: I used to always fly braless because I didn't want to be uncomfortable during the flight. That was until one day when the paparazzi captured me on my way home. I was wearing a modest black top—nothing crazy, or so I thought. By the time the car dropped me off at home, there were practically topless pics of me all over the internet. A tip that I have especially appreciated since is swapping my bra out for a bralette or bandeau. You wouldn't think that these wireless, thin pieces offer enough support, but they do (and this is confirmed by my bustier friends!). Neither style will dig into you or create any discomfort at all. Victoria's Secret has an entire line of adorable prints and colors that come ruched, lined with lace and even reversible, for less than $25. In the warmer months, I like to wear them under oversized tank tops and off-the-shoulder tees, too.

Now that you're looking and feeling good, it's important to treat yourself well while up in the air. No matter what you have on, if you look and feel haggard after a long flight you may as well be wearing UGGs with oversized sweatpants. (But not really.) My best beauty tip is to apply heavy moisturizer and eye cream to a clean face and be sure to drink extra water throughout the travel day. At least a few days before my trip, I like to pull out a rack and begin setting aside what I will be packing. Rolling racks are an organized girl's dream. (I go into more detail about them in chapter 2.)

Years ago, Paris and I were asked to be in an episode of *Sex and the City*. Even though it wasn't yet the phenomenon it would become, we were very excited to be part of the show. The episode we were booked for was the one where Samantha Jones had moved to the Meatpacking District. She couldn't get any sleep because of the loud transsexual hookers on the street below. Originally, it was supposed to be Paris and me who were living next door and making the ruckus with our late-night parties. Would you believe that we missed our flight from LA and had to be replaced? Talk about the regret of a lifetime!

3

Consider what the 3s for your trip will be.

Before you start pulling looks, consider the obvious details of your trip. Where are you going? What will the weather be? Are there cultural standards that you will need to adhere to? For example, if you are visiting the Middle East, you'll need to bring along some modest options to be respectful in religious areas. What is your purpose for travel—business, pleasure or both?

Consider what the 3s for your trip will be. When I'm packing for Hawaii, my three occasions to dress for are beach, loungewear and evening casual. When I go to Miami for a work and play trip, my 3s are business meetings, pool play and fun nights out.

Once you have an idea of what your trip will look like, begin to pull pieces for your 3s. I like to categorize my outfits on the rack by activity. Furthermore, I put together entire looks from head to toe so every aspect of my outfit is covered. I keep the looks together when I pack them in the suitcase. This way, it's much easier to find an outfit as opposed to sifting through your bags and creating clothes chaos.

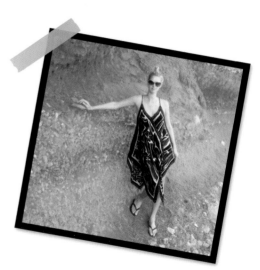

I still stick to my trusty 6s when traveling. If you're going away for a long trip, this doesn't mean you should pack only six items, but be sure you cover those six staples when packing. Like the seasons, they change depending on the destination. Choose interchangeable pieces by sticking to a theme or color palette so

your staple items can be mixed and matched to a multitude of looks. This doesn't mean you should pack all black or all teal. This does suggest that you stay in the same range of complementary shades.

A perfect day-to-date item is essential when it comes to packing for any trip. Whether it's a tunic, dress, jumper or jumpsuit, if it's a staple that can be worn multiple ways in various settings, dressed up or dressed down, pack it! It will save space in your luggage and valuable vacation time that shouldn't be spent on deciding what to wear. All it should take to transform not only the look but also the function of this versatile option is a simple change of accessories.

This Roberto Cavalli dress is actually a cover-up that I bought in Monte Carlo. It has since become a must-have for many of my trips, including this one to Europe. As you can see, I wore it as loungewear, to the beach and out and about in the city.

5

Accessories are where I tend to go overboard. I used to take every little thing with me, just in case I needed it. Now, I am selective about what makes the cut. I place accompanying shoes under the rack and lay the jewelry over the outfits to confirm the complete looks.

I always pack a pair of solid black or nude pumps. They are a great day-to-night item that go with everything. On the same note, I take a neutral handbag, even if it isn't needed for the staples

128 I am bringing. You never know what you might purchase and this way you have the option of wearing your newest find right away!

Travel tip: Never travel with valuable jewelry or expensive items in your suitcase. Always put them in your carry-on.

If I am bringing more than one piece of luggage, I always make sure both suitcases have equal pairs of shoes, T-shirts, jeans and underwear. I split it up so, in the event that one is lost, I have at least something to wear.

When it comes to checking luggage, I never let expensive luggage out of my care and check only inconspicuous luggage on wheels. I am still traumatized from an experience I had in high school. I was visiting my boyfriend, who was away at college in Boston. I packed my Louis Vuitton rolling suitcase with all my favorite things (I was excited to see my boyfriend and wanted to look good!). When I landed at Logan Airport, I sat by the carousel only to find there was no Louis Vuitton luggage on it. Someone had stolen it! It was my first trip visiting him and we had the whole weekend planned, but I had nothing to wear. Nightmare! I filed a report with the airline and never got any of my things back.

My travel 6s and 5s

Snow 6:
Extra-warm coat
Puffy vest
Fleece-lined leggings
Jeans
Long-sleeved day shirt
Dress

Snow 5:
Booties
Tall, flat boots
Scarf
Hats
Gloves

Sun 6:
Tunic
Shorts
Day-to-night dress
Romper
Bikini
Shorts

Sun 5:
Gladiators
Jeweled flats
Sunglasses
Beach proof carryall
Day-to-night handbag

To save space in my suitcase and prevent my purses from loosing shape, I stuff them with other items I'm packing. I roll up T-shirts and stuff them into my Chanel Jumbo, fill my tote bag with sweaters, and another purse with sunglasses (which also protects them from breaking).

Ziploc bags are essential for packing. I pack my shoes in the larger freezer type to prevent scuffing and keep attached crystals secure. The added benefit of Ziploc bags is that they make for easy viewing and you can see what you're working with without having to unpack everything. I use all clear bags for everything: makeup, toiletries and so on. Why make things harder on yourself by playing the guessing game when it comes to finding your things?

Most importantly, don't forget to pack a positive attitude (crankiness is contagious!), be open to new adventures, act street-savvy, be safe and, of course, take lots of pictures!

Pack a mini portable steamer if you plan on wearing anything that wrinkles. I bought mine from a kiosk at a mall in Las Vegas for around $30. They are light, easy to pack and can really save you in a pinch. You have no idea how many times mine has come in handy!

...Or at Home Whipping Up Some Pasta Carbonara

WHEN IN ROME

"It is Good
to Have an End
to Journey toward,
But it is the
Journey
that Matters
in the End."

ERNEST HEMINGWAY

I love New York and LA. It's been a blessing to live on both coasts (and sometimes a curse, when I'm stuck in freezing rain in NY or freeway traffic in LA). But there's nothing more invigorating or exciting than being far from home and stepping foot in a new part of the world.

Seeing the world is a privilege I never take for granted. That being said, I don't believe you need a well-worn passport to play around with international style. Sprinkling your wardrobe with bits and pieces inspired by a variety of destinations near and far not only will spice up your day-to-day look, but also can put you in a Honolulu state of mind—even if you're really at home watching the *Housewives*.

Here is a list of some of my favorite destinations, how they've influenced my personal style and how you can apply it to your own.

Tokyo

Tokyo is one of my favorite places in the world to visit. There really is nowhere in the world more style-savvy than Tokyo. Everyone knows about the eclectic aesthetic of the Harajuku Girls (thanks to Gwen Stefani, a fashion icon in her own right), but it's not about having Technicolor hair or anime-inspired accessories. Sure, there are trends galore, but there are no strict rules or expectations, either. And because there are so many style subcultures, you can try on a different persona every day (or every few hours!) and really experiment with your look. I always feel a sense of liberation the second I step off the plane in Japan, knowing I can play with my style, change it at a moment's notice and never feel out of place or judged.

I first had the opportunity to travel to Japan when my sister and I were chosen as the faces of Tokyo-based handbag company Samantha Thavasa. I was only seventeen, and it was like a dream when the company asked me to design a line of bags for them. Things got even more dream-like when *Sex and the City* costume designer Rebecca Weinberg was handpicked to style the campaign! Everything about the experience was beyond fabulous and we had such a blast. The brand essentially wanted to style us like Barbie dolls: big blond hair, drenched in pink, rocking extra-girly, glittery

> There really is nowhere in the world more style-savvy than Tokyo. ♡

bows. It seriously felt like playing dress-up and, to me, that is
so indicative of Japanese style: fearless, fun and over the top.
I remember when I stepped off that plane with my sister and we
were greeted by fans holding giant posters and signs adorned
with our faces. We had no idea how popular we were in Asia,
and it would be the understatement of the year to say we were
a little shocked. But we didn't have time to be paralyzed by fear
(as tempting as it was to stand there speechless with wide eyes
and dropped jaws) because once we got to the hotel, we were
put right to work.

Our days consisted of photo shoots, television interviews, auto-
graph signings and campaign shoots. It was nonstop, but so
exciting. I actually cherished every second. When we had an
hour off from our crazy schedules, we did what any sane, jet-
lagged travelers would do: hit the shops! We couldn't even bear
to think of napping in our downtime when we knew there was a
veritable style playground right outside our hotel.

136 But because it was widely known that we were in town, and it's pretty hard to stay incognito as two platinum blondes in the streets of Tokyo, we had to go undercover. We wore dark wigs with sunglasses and donned medical masks that many Japanese locals wear during allergy season. The disguises worked! And I'm not going to lie—it was pretty fun getting to play dress-up for a different reason.

With our spy gear on, we discovered one of my favorite places to shop in Tokyo— Shibuya 109. It is a ten-story megamall full of the coolest, most distinctive shops you can imagine. While there, we picked up so many amazing pieces, like cute printed tights and socks, adorable cell phone charms, sparkly costume jewelry and, of course, purses galore.

What I find most inspiring about modern Japanese fashion is the absolute fearlessness about expressing your unique individuality. Even if you don't want to commit to a head-to-toe theme (like the very popular Gothic Lolita look, complete with girly ruffles and smoky eyes), you can introduce some Japanese liveliness into your day-to-day life with a few simple accessories. The fashion rule in Japan is that there are no rules. Think about what appeals to you and, above all else, have fun!

Hawaii

Almost every Christmas, my family and I go to Maui for the holidays. Given our jam-packed schedules, it's hard to get everyone

together during the rest of the year. So it's really nice for all of us to relax and catch up, even if it's just once every twelve months.

Besides the white-sand beaches, crystal-clear waters and balmy breezes, one of my favorite parts of traveling to Maui is...packing. Really! The reason? It's so incredibly easy. Hawaii is one of the only places in the world I can travel to with just one suitcase because everything fits. My island wardrobe usually consists of the obvious must-haves, like bikinis, shades, SPF and sundresses, but I also make sure to pack my favorite Missoni and Tolani caftans for a bit of coverage.

And—this is really important—I don't bring *any* high heels! I strictly stick to flip-flops or sandals. I take a break from other high-maintenance habits, too: I don't bring a blow dryer or any makeup. Sound scary? Trust me, it's not. Once you're in the swing of 24/7 beach life, you forget all about concealer and blush. I take the opportunity to really let my skin breathe and give my hair a break. I consider it a total mind-body-soul vacation. I try to bring that relaxed vibe back with me, even when I'm in the midst of my hectic city life.

Hawaiian locals take such pride in their beautiful hang-ten haven and it is reflected in their style. The easy-breezy lifestyle begs for light and airy attire, most of which is printed with vibrant island flowers like hibiscus and plumeria. Hawaiians honor tradition by giving and receiving leis, garlands made of fragrant flowers

138 worn around the neck, as a sign of affection. By honoring their local pride, the ladies look like birds of paradise themselves. On a sunny day, no matter where I am, I channel my inner Hawaiian by mixing tropical floral patterns or simply tucking a real flower into my hair.

St. Tropez

St. Tropez was exclusively a hub for artists and other creative types until legendary movie star and bombshell Brigitte Bardot put it on the map with *And God Created Women* in the '50s. Soon, the glitterati followed: royalty, celebrities and sun worshippers.

I've been going to St. Tropez since I was a teenager. Located in the south of France, it is a playground for the fashion set. It has the best beaches, the finest shops and restaurants, and probably the best night-life I've ever experienced. It also promises to produce the perfect sun-kissed bronze glow, even after you slather on several coats of sunscreen.

While St. Tropez naturally has every big-name-brand store from Chanel to Pucci, the real finds are in the random shops along little alleyways and by the port. I like to walk over

> The real finds are in the random shops along little alleyways and by the port.

to the docks and buy cute, colorful, braided friendship bracelets from the local street artisans for all my girlfriends. The town is filled with treasures that you can only find there. I have bought some of my favorite swimsuits, sarongs and one-of-a-kind baubles at the little shops that are found in these unlikely locales. Walking around St. Tropez, you're likely to cross paths with Kate Moss or Karl Lagerfeld, scoping out what's for sale, too. For the past few years, Chanel has set up a pop-up shop during the summertime so all the fashionistas can get their Karl fix on vacation. Iconic designer Roberto Cavalli's yacht is usually docked at the port. It's pretty hard to miss. Here's a tip if you're looking for it—keep your eyes peeled for the iridescent purple boat with Cavalli's signature cheetah-print pillows sprawled all over the deck.

So, yes, there is a reason the Cannes Film Festival is known almost as much for its red carpets and cinematic highlights as it is for the decadent yachts and come-hither beaches. Something about the French Riviera air seems to inspire effortless elegance. My favorite thing about traveling to St. Tropez or Monaco is the array of eye-popping color dotting the streets and beaches. There's a certain joie de vivre that encourages the vivid hues and results in a kind of glamour that is confidently cool, rather than forced. As far as I see it, the secret to pulling off Riviera style is seriously abiding by the less-is-more principle. A splash of coral or turquoise can go a long way against a crisp, white base.

London

While I have a special place in my heart for sun and sand, London is one of my top ten favorite destinations, hands down. The city has so much culture and history, and the fashion, of course, is next level. No one has better style than the Brits (see the aforementioned Kate Moss, Alexa Chung, Victoria Beckham and Stella McCartney, not to mention Lily Cole, Agyness Deyn, Emma Watson and so on). As opposed to Hawaiian style, which requires just one light carry-on bag, London life requires a lot of luggage because the chilly air calls for so many more layers. Chunky sweaters, coats, scarves, hats—the list goes on and on, and the suitcases get heavier and heavier. Plus, I do a lot of shopping when I'm there. Did I say "a lot"? I meant A LOT in all caps.

Topshop is always a go-to destination for shopping when I'm in London. The Topshop brand has expanded all over the world, but, in my opinion, nothing beats the expansive flagship store at Oxford Circus in London. Four floors of fashion make for a whole afternoon of scouring the racks and try-ing on everything from dresses to blazers to headbands. London is also known for its great selection of vintage shops, mar-kets and "high-street shops." A high-street shop sells high-end clothing without the sky-high price tags. Zara and H&M are two examples that instantly come to mind.

Luckily, both have made the jump across the pond, so I can still browse their racks back home. Some of my other favorites are River Island and Accessorize.

My favorite sample sale of all time was the Christian Louboutin sample sale in London. A girlfriend of mine invited me as her plus-one. I was so excited! I'd heard tales about the infamous Christian Louboutin sample sale, but I had never been there before. They mark items down up to 80 percent off! We drove down to the headquarters, entered the office and walked into a big room full of clear containers. Each bin was labeled by size and was filled with shoes in see-through plastic bags that protected them and made it so that lucky shoppers could clearly see what was inside. There must have been over one hundred of these bins. Christian Louboutin handbags were displayed on tables. After browsing the sale for an hour, I walked out with ten new pairs of shoes and six purses! I scored an amazing Swarovski-encrusted pair of heels at over 80 percent off retail! I still keep them in the see-through plastic bag to prevent any stones from falling off. I also bought my sister a pink Swarovski clutch at 70 percent off retail! She had just bought the same clutch in white and when I saw sparkles and pink, I knew she had to have it!

My Louboutin sample sale scores from London!

I especially appreciate the way Londoners dress for aesthetics and practicality. Sure, stilettos can look absolutely killer, but they can also be absolutely killer if worn on a slippery, rain-soaked,

142 cobblestone road. Chic riding boots and stylish flats are comfortable enough to walk all over town in, but are still style-friendly. And while bare legs may be fine for the rare sunny days in Hyde Park, the unpredictable (read: overcast) weather is terrific for experimenting with different types of tights and leggings. Mixing up textures and patterns is a great way to subtly infuse personal style into an outfit that may otherwise be bundled up under layers of cold-weather gear.

Just because it's chilly enough to warrant a warm coat or a light jacket doesn't mean you have to sacrifice style, and Londoners definitely do this right. Here's proof—the Burberry trench, a timeless coat that defines *refined,* was born there.

> Mixing up textures and patterns is a great way to subtly infuse personal style into an outfit.

Aspen

Aspen is another favorite Christmas destination for my family. It's basically the equivalent of our Hawaii holiday trip, but with a lot more layers. It's such a great vacation for my family because we get to spend every day and every night together. We typically wake up in the morning and have a big breakfast all together as a group, then hit the slopes as a pack, meet up at the bottom of Ajax Mountain for a family lunch, and go out for a low-key, cozy dinner

at night. We all really appreciate the chance to bond, and I cherish the 24/7 closeness.

As we have all grown up and carved our own paths, we travel so much that we rarely get to live under one roof for any period of time. Family is so incredibly important to me, and it really is nice to have them close. They are my foundation, and I count on them to give me strength, guidance and support. They have been by my side through the good and the bad, and I have stood by them through it all as well.

It's so bitingly cold in the mountains that the only real respite is in the folds of a super-cozy puffy jacket. My favorites are by North Face and Pucci, whose designers have somehow found ways to make the puff look posh. I also load my suitcase with tons of hats and scarves, and make sure everything is as soft and inviting as possible, given the less-than-tropical climate outside the cabin.

Packing for Aspen can be super-tricky. Bringing along one small suitcase, as I love to do for Hawaii, is just not an option. Besides, my favorite puffy jackets, heavy boots, fluffy scarves, warm hats and cumbersome ski gear are anything but compact and it all quickly adds up!

But even though you are practically buried under layers upon layers, there is still plenty of opportunity for originality in Aspen. My sister gravitates toward head-to-toe cheerful pinks and purples to liven up her entire snow-bunny look, whereas I tend to go for

144 neutral tones and dark shades with one bold statement piece thrown in the mix. Either way, we are both toasty warm and ready to have a good time.

Aspen fashionistas rock some serious style on the slopes (and around the fireplace). For anyone who loves being cozy and comfortable sans the Snuggie, Aspen is the place to be. In this winter wonderland, the yummy, soft fabrics and plush pieces are pretty much heaven on earth. When I am not hitting the slopes, I love to snuggle in my plush attire while hitting the après-ski scene and drinking hot chocolate in the lodge.

Milan

Milan is absolutely synonymous with fashion. The most important Italian labels, including Dolce & Gabbana and Prada, are based there. People take style seriously in the city, and the abundance of sharp tailoring, smart accessories and sensual silhouettes are always intriguing.

Women in Milan carry themselves with a kind of head-turning grace that I think is so admirable and beautiful. They dress for their body shapes and always exude an internal confidence that no amount of money can buy. As style icon, silver-screen goddess and proud Italian Sophia Loren said, "A woman's dress should be like a barbed-wire fence: serving its purpose without

Women in Milan carry themselves with a kind of head-turning grace.

obstructing the view." I couldn't agree more and Milanese women subscribe to this figure-flattering philosophy. To channel some of this philosophy, don't be distracted by current trends that may not work for your body; focus instead on what you love about your shape and find clothes that show it off.

I first went to Milan as a guest of another incredibly influential top designer, Roberto Cavalli. Roberto and I became friends in New York, and have kept in touch despite the cross-Atlantic commute. He's an incredible designer and such a talented, charming man. He flew me out to his home turf to walk in his Just Cavalli show and be his guest at the Roberto Cavalli collection show. The first day I arrived in Milan, I went to the showroom to do a fitting for the Just Cavalli show with his team. I was set to close the show, and we settled on a short, red dress for the finale. Later that night, I went to dinner with Roberto and a few friends at his restaurant, Cavalli Cafe. Italian cuisine is my favorite food by far, and the dishes we dined on that night were the most amazing I'd ever had. We indulged in fresh mozzarella and beautiful pastas, and the restaurant's

146 tablecloths were all done in Roberto's signature animal prints featuring cheetah spots and zebra stripes—so cool!

The next day I walked into hair and makeup for the show. All the supermodels—Isabeli Fontana, Miranda Kerr, Gemma Ward—were already in their robes, getting ready. They had generously made me a makeshift dressing room. After I was made up, I headed to the runway to prepare for my strut. Before I went out on the catwalk for the Just Cavelli show, Roberto gave me a high five and with that much-appreciated confidence boost, I closed the show. It was so thrilling! When I made it backstage, we all toasted Roberto with champagne and raised a glass to his incredible new collection. To top off an already-surreal evening, I walked back to my dressing room only to find none other than Rihanna there with her makeup team, getting a last-minute touch-up before a photo shoot.

Later, Roberto invited me back to the showroom to choose an outfit to wear to the show for his eponymous label the next evening. Once I walked in, he took my hand and led me to the showroom that was overflowing with his gorgeous clothes and packed from wall to wall. He said, "Pick a dress to wear to the show tomorrow. Also, I know your birthday is next week, so pick whatever you want as your birthday dress. My gift to you." Incredible, right?! There I was, standing alone in one of the most famous ateliers in Milan, able to pick out whatever my heart desired. It was a true Cinderella moment. After sifting through the racks, I decided on a purple, knee-length floral for the show and a pale pink sparkly long-sleeved minidress for my birthday. I couldn't have felt more like a princess.

I went to the Roberto Cavelli collection show later that evening. It was quintessential Roberto—sexy, bohemian and bright. As if my Milan experience hadn't already been bizarre and beautiful and over-the-top-glamorous, I sat down at dinner to find myself seated next to Jay-Z. Now that was a memorable trip!

Australia

The first time I traveled to the land Down Under was when my sister was shooting the film *House of Wax*. She lived in Australia for three months, so I took the opportunity to pay a visit. On her weekends off, Paris and I would travel down to the Gold Coast and stay at the Versace Hotel. There is no other way to say this: It was *very* Versace. Everything around us was emblazoned with the iconic Versace logo: Versace soap, Versace towels, Versace chocolates on the bedside table, even a Versace boutique in the lobby.

Months later, I headed back to Oz to do some work of my own. My sister and I hosted the Melbourne Cup, which is a famous horse race where everyone gets dressed to the nines and wears the most amazing fascinators (those adorable and often-hilarious tiny hats that became even more famous after the Royal Wedding in 2011).

148 When we arrived at our hotel room, we were greeted by racks of Australian designer clothing and dozens of those teeny-tiny hats stacked up to the ceiling. It was the first time I had been introduced to Aussie designers, and I loved the glamorous yet bohemian feel. I developed some favorites pretty quickly—my top picks were Sass & Bide, Wayne Cooper and Rachel Gilbert.

Several years ago, I had the honor of walking the runway at Australian Fashion Week and I got an even better sense of how they do things Down Under. While Europeans tend to be more tailored, Aussies keep things loose and casual. Perhaps it's the New Yorker in me that's drawn to the Euro way and the California girl who can't resist the relaxed Aussie vibe. Australia's sense of endless-summer comes largely from its landscape, which ranges from rugged outback to pristine beaches, and the multitude of outdoorsy attractions that make it hard to stay out of the sun for long. I always leave Australia with a penchant for flirty day dresses, playful patterns and colors that keep my sunshiny mood going long after I've boarded the plane back to the States.

South Africa

I went to South Africa a few years ago with my sister and our cousins—a total girls' trip. Our first stop was Johannesburg for a safari. No one was sure what to pack. We wanted to be comfortable, but retain a little bit of style. I decided on a uniform consisting of jeans, T-shirts, sneakers and army jackets.

Over the next few days we stayed in huts (which were thankfully nice enough that they included electricity, air-conditioning and even cable!), and we saw everything from hippos, to elephants, to cheetahs, to zebras. It was such an amazing experience being in the middle of a jungle with my closest friends and family, and it was an opportunity I'm forever grateful for. After getting in touch with nature for a few days, we departed to Cape Town for the World Cup—such a special once-in-a-lifetime trip! The stadium was freezing and I've never in my life heard a crowd roar like that (my ears were still ringing days later), but it was wonderful in every way.

One style I love to borrow from South Africa is mixing and (mis)matching prints of all kinds. We're often told that certain zigs shouldn't be paired with other zags, but that sort of mixing is welcomed and encouraged on the streets of Cape Town. When it's done right, it looks fresh and feminine. You thought I was going to say leopard print, didn't you? Okay, that too!

Miami

I *love* going to Miami. It is such a nice escape from New York City during the freezing-cold winter months. It's an amazing feeling to be able to slip into a bikini while it's snowing back home, and I am always so, so grateful for the change of venue.

150 Everything in Miami screams sexy. The locals, nightlife, beaches and more are an explosion of vibrant color, opulence, liveliness and spice. Miami is an influential fashion capital in its own right, and it is no surprise they say that the sexiest people live in this international playground. I am a firm believer that how you dress affects your mood. It's pretty difficult to feel dark and down when you are draped in coral, pink, turquoise, yellow and, my favorite, robin's-egg blue. Miami fashion is luxurious and glitzy, but it's also happy and uplifting!

Some of my favorite times to visit Miami are for New Year's Eve, for the famous Winter Music Conference, and for Art Basel, a huge event where the most important, influential galleries showcase modern and contemporary artwork throughout the city.

I flew down to Miami with a few of my best girlfriends last December for Art Basel. We wanted to do double duty by checking out all the cool artwork and getting some sun at the same time. Many fashion brands put on impressive events during Art Basel, and I had it on my itinerary to head to the Diane von Furstenberg luncheon at the Soho House. I knew it was a beach barbecue, and I wanted to dress accordingly. So I'd packed a long, tie-dyed Gypsy 05 sundress with Diane von Furstenberg wedges.

On my way into the barbecue, I spotted a cute little kitten playing in the trees. Anyone who knows me (and anyone reading this

How you dress affects your mood.

book) knows that I am obsessed with cats—I have two. I knelt down to say hello and the kitty actually walked straight into my arms. She was so incredibly tiny, she literally fit in the palm of my hand! The waiter at a nearby restaurant looked over at me and said, "This kitten has been living here since she was born. We have been trying to find an owner for her."

My heart skipped a beat. "Really?" I asked, the wheels in my brain already turning. I pondered it for a second and then scooped the kitty up and headed back to my sister's room at the Fontainebleau hotel next door. I knocked lightly on her door, and when Paris answered, she looked me up and down and the surprise was all over her face when her eyes settled on the miniature kitten I was clutching to my chest.

Art Basel, Miami

I called room service and ordered some tuna for our new friend, and we made sure she had a good meal. She was starving and ate an entire plate of fish in less than a minute. Then she thirstily gulped down a bowl of water, and we were happy to just watch her indulge. I played with her a bit, and then Paris and I left her in the room to relax while we went to the luncheon.

I came back after the barbecue (which was fabulous), picked her up from Aunt Paris's room and brought her back with me to my hotel. I walked across the street to a CVS, got her a litter box and cat food,

152 and really started to settle into the idea of being this kitty's caregiver. The next day, I opened the *New York Times* and saw my kitten on the cover of the Style section, perched on the lap of Demi Moore! Apparently, Demi had bonded with the kitten the evening before at the Chanel dinner, which was held at the Soho House. I flew home to New York City with my now-famous kitten, and she has been living with me ever since.

My precious Mac! She got her name because she loves to cuddle with my computer.

Paris

J'aime Paris!

It almost seems silly to include Paris on a list of inspirational, international style capitals, because it is just so obvious that it could top the list. (Not to mention the more obvious conundrum that I have a very stylish sibling by the same name.) But there are so many elements of Parisian culture that are worth borrowing that I couldn't bear to keep the City of Light out of this chapter. Paris is arguably the fashion capital of the world and is included in a very elite list of fashion tastemakers known as the "Big Four," alongside

Parisian fashion embodies a sense of flirtatiousness and effortless elegance.

New York, Milan and London. Some of my favorite designers hail 153
from Paris: Isabel Marant, Christian Dior, Alaïa and Valentino, to
name just a few. Parisian fashion embodies a sense of flirtatious-
ness and effortless elegance that no one can hold a candle to.

Charles Worth, an Englishman living in Paris, became the
father of modern haute couture when he began putting
his name on the labels of his design and then started
modeling his original designs for clients on real women.
His innovative concepts soon caught on. Thereafter,
designers knew that if they wanted to be successful,
they had to show their collection in Paris and form
their own label.

I went to my very first haute couture show in Paris.
Donatella Versace invited my family to attend the
2003 Versace show and we were all beyond
excited. We went to the Versace boutique on rue
du Faubourg Saint-Honoré for a fitting, and I had
the opportunity to pick out a dress for the show
and the after-party hosted by Diddy. My sister and
I picked matching low-cut chiffon dresses—she opted
for pink (obviously), and I chose blue (naturally).

I remember walking into the show and being in complete
and utter awe. The runway was strewn with roses (which
I later found out had been imported from Italy for the occa-
sion) and then encased in clear glass. It was absolutely
beautiful. I had been to New York City fashion shows but
had never seen anything like the production of an haute couture
show. It was on a completely different level—no one does fash-
ion like Paris!

154 After the show, we met Donatella backstage. She was everything I had imagined: tanned, platinum-blond, smoky-eyed and smoking a cigarette. The backstage area was hectic and other attendees like Heath Ledger, Rupert Everett and Naomi Campbell were milling about all around us.

During that same trip, we were also invited to the Valentino show. The show was incredible and the after-party was even more astonishing. We went to Valentino's Paris home and I distinctly remember Karl Lagerfeld coming in to photograph the party for one of his spreads in *Vogue*.

I can see why Karl felt compelled to snap candid shots. Fabulous French women always look pulled-together, effortlessly stunning, tailored to perfection and yet still manage to seem completely natural and at ease. They invest in select pieces and treat their wardrobe kindly. The French sense of style is only one characteristic to covet. We will forever be scratching our heads over how in the world those women stay slim in a city filled with pastries and champagne. Much like the other Paris: Hilton.

Greece

Greece is a magical place. Not only are the sights and food spectacular, but so is the style. Think about how many trends hail from Greece: tunics, togas, wreaths, key patterns and so much more. Many of the trends we're used to seeing in top fashion magazines originated as everyday staples of ancient Greek life. Greeks and Romans may have had their ups and downs, but one

thing we can all agree on is the must-have status of gladiator sandals. The cage-like shoes started in Rome and had an influence on Greeks. What were once worn as the official footwear of great gladiators who fought inside the Colosseum are featured today all over the runways of Chanel and Yves Saint Laurent. That's impressive staying power.

I showed my Nicholai collection at Athens Fashion Week in 2008. I had all sorts of romantic visions of Greece before I'd ever been there. I was sure the entire country was nothing but stunning, blue-roofed buildings overlooking an orange-sunset-lit Mediterranean. And, to be honest, I wasn't that far off. When I put on a show there, I was floored by the dreamy look and feel of the atmosphere, and how that influenced the style on the streets. Even though Athens is a major metropolis, the island ambience definitely reflects how people dress.

There was a distinctive Greek-goddess vibe resonating in the clothes, and it reminded me why soft draping, one-shoulder dresses and feminine lace never seem to go out of style. The appeal of those classics is pretty irresistible, and it's hard not to feel a bit more poised when you're incorporating some Aphrodite-inspired pieces into an otherwise contemporary look. Sometimes all it takes is a halo of braids in my hair or a dusting of shimmery powder to create an ethereal aura that feels sweet and Greek-like, without going overboard.

Never
Get Lost
– or Lose
Yourself
– Again in
a Fashion
Frenzy

SHOP- PING GPS

"I Don't Think Women Need Another Black Bag. Everybody has a black bag already, so I thought this Season Needs Color."

CAROLINA HERRERA

There is a certain mind-set one must adopt in order to have a productive shopping excursion. In a perfectly practical world, one would set off to a shop in search of a specific item, enter the venue with droid-like vision, bull's-eye activated and blinders up. Once the mission was accomplished, one would exit having made their single intended purchase. This all seems so simple and obvious when said out loud, although there is one teeny-tiny problem here. We are not machines. We are women. And we love to browse through beautiful things.

Pre–3-6-5 a typical trip to a department store looked like this: I would zigzag around the store, loading up my arms with anything I loved or could love. In the dressing room, I would designate

160 "Love It" and "Leave It" sections for hangers and just go to town. If I loved it on the hanger and it fit me perfectly—I was sold. If I kind of loved it on the hanger and it fit me perfectly—I was sold. If I loved it on the hanger and it kind of, sort of (sometimes not really) fit me—I contemplated if I could or should make it work later, and I often just could not resist the temptation and ended up being sold on it after some pretty weak rationalizing. This type of reasoning led to too many purchases and one completely confusing closet.

Today, I still love to hug an armful of frocks and play dress-up in the dressing room. Where is the fun in checking out the latest and greatest if you aren't going to try it on yourself? The difference between smart shopping and silly acquiring (bordering on troublesome hoarding) is what happens between trying and buying. Just because you like something does not mean you need to own it (blasphemous thinking, I know, but stay with me for a second).

Department stores, in particular, are designed to inspire our over-indulgence. They are so large and overwhelming that we go in and get lost in the maze of oohs and aahs to the point where we end up buying things that we do not really need—sometimes, things that we do not even really like! The biggest trap of all is the sale rack. Like moths to a flame, we get sucked into those racks, hunting for that one (or five) great find(s). It feels like we're playing some sort of lottery when we score a piece that really "should be" more expensive for a really low, great price. We won! We found it!

Whether we love it or not! It would be brainless not to buy it! But, I beg you, do not buckle to this type of trickery. Give it a critical eye and ask yourself if you would be buying the item at full price, or if what you are truly buying into is the idea of getting something for a sweet deal.

I loved the movie *The Blind Side* for so many reasons, one of which was the fashion advice Leigh Anne Tuohy gave to Big Mike when she took him shopping for clothes. After Big Mike's lukewarm response to an article of clothing, her sage advice for purchasing clothes was this: "Well, one thing I know about shopping is that if you don't absolutely love it in the store, you won't wear it. The store is where you like it the best." It is at that moment, after all, when you are making the investment, whether big or small.

Compare a fashion shopping excursion to one for furniture. You would probably not ordinarily stop by a furniture store simply to see what's new on the market and looks good on the floor (unless, of course, you are a furniture designer, in which case, replace *furniture store* with *hardware store* or something similarly random and unaffiliated with your daily life!). You would go into the store on a mission. You would know that you were looking for an end table or a comfy couch and what sort of color scheme you had in mind.

Nobody would enter the store and think, "This dining room table is on sale! And so is that one! I don't love-*love* either one and I only have one dining room with space for one table, but, hey, what a steal pricewise! I will take both home, including the four chairs that come with each one, and, oh hell, at that price, I can't resist taking five more, and throw in that rug, too. Just because." That house would look like a hot mess. In the worst-case scenario, that house represents your closet!

162 My advice is to go into any store with a goal, the mind-set that you are looking for a leather jacket, for example, and do not be sucked in and sidetracked by the alluring wallets or sweaters or accessories that are there to derail your mission. Now that you understand my 3-6-5 method, the next time you find yourself in a store, you should ask yourself: *Where does this item fit into my 3s? Will I wear it to work, on dates or to special occasions?* If you can't pinpoint where you will wear it, you should not be buying it. Also ask yourself: *Is this my style? Does it reflect how I want to represent myself to the world?* If it passes your 3s, then consider your 6 or 5 list. Is it a staple or a trending item? You already know not to invest too much in anything too trendy. By keeping these words of fashion wisdom in mind when shopping, you will keep your closet and your spending in check! Not to mention, I guarantee you will feel so proud of yourself for keeping it under control, you will not miss the passed-over items left behind.

Vintage:
Clothing and accessories that were produced from the 1920s to twenty years before the current date.

Navigating Vintage

I travel a lot for work, so I am constantly exploring new places. When I have time off, I like to check out the local vintage shops. I do some internet research to find the best places and set aside some time to go explore. Last time I was in Dallas, I found a great designer vintage store online and I snatched up a beautiful, mod Balmain dress from the '70s for just about $100! It was way too big, but I could not resist. I made sure to immediately take it to the

tailor to be altered when I got home (more on tailoring in a bit).

Vintage shopping can be pretty overwhelming. There are typically racks and racks of clothes, accessories and shoes lining the floor, and they may not be organized in the color-coordinated or otherwise-inviting ways you are used to finding in a boutique or department store.

The first thing you can do to make the experience a bit less daunting is zero in on one rack and dive in. Do not try to take in the store as a whole. Instead, keep in mind that you're seeking out the diamond in the rough, so start searching methodically. Inspect the pieces in front of you and really see if you can tell how much work went into making them wearable. I do not regularly make a habit of judging books by their covers, but, in this case, I advise you to judge away. What is your first impression of the piece? Does it look cheap or as if it were thrown together poorly? If so, move on. If you think there might be something special about it, pause and consider the following.

164 If the piece is not exactly what you had in mind, but there seems to be some potential there (and the price is not so extravagant that you could not imagine cutting away some of its fabric), think about what you might be able to do to make it yours. Use your imagination—if you removed the sleeves, shortened the hem, cropped it, nipped it at the waist or even dyed it—would it suddenly become something you would pay top dollar for? Feel free to mentally restyle dowdy finds— what would happen if you chopped them up? Could you bring them up-to-date and make them match your own sense of style? Try to develop a real eye for what could be done to a "maybe" item to make it a "yes" item. If all it requires is a new zipper or a few buttons to update it and make it look current, bring it to the dressing room!

A note on alterations: You already know that I am a big advocate of tailoring, which can sometimes even involve totally redesigning a vintage piece. When you walk into a vintage shop, do not be turned off by all the long, matronly dresses. With a little tailoring, you can chop a dress in half and make a formerly frumpy frock short and sexy. I fell in love with a colorful purple-, black- and red-striped dress, but it was long and totally unflattering. I took it to the tailor

When vintage shopping in LA, I fell in love with this dress because of the cool '70s print. I looked past the fact that it had no shape and was ten sizes too big for me. Instead, I hacked the hemline and used the extra fabric to create a tie to cinch the waist.

and pretty much had him chop off the entire bottom half. I ended up wearing it to a friend's party the very day it was ready!

Here is the catch, though. Are you really committed to taking pieces to the tailor or altering them yourself? If you are super-handy with a needle and thread, or you know you will take that dress to the tailor first thing on Monday, then, by all means, buy it. But if you know you are the type of person to *say* you will get something altered but never do it (you can be honest—there is no judgment here!), then avoid the temptation to buy a so-so piece. It will just eventually be another unwearable item taking up valuable space in your closet, and that is exactly what we are trying to avoid. Be totally candid with yourself: Are you committed to making the changes to make the piece wearable? If not, that's okay—but put it back on the rack and move on.

Some of my favorite items to look for when I hit the thrift shops are vintage slip dresses. They are girly and romantic and can be worn to so many different events. I have had linings sewn into slip dresses so that they are suitable to wear out at night when paired with a leather jacket. I like to look for different kinds of prints and styles. While you will encounter a lot of lackluster items in your vintage shopping, and many pieces that were not built to last, there are always some diamonds in the rough. A lot of careful craftsmanship went into clothing design in previous decades that isn't necessarily the case anymore in most chain-store merchandise. So in vintage stores you can find some bright, colorful, one-of-a-kind pieces that are expertly made and will last for years to come.

166 My mother gave me a lot of her vintage Zandra Rhodes dresses, which she has not worn since the '80s. I was stoked to inherit them, but I had to update them a bit to my liking. I first got rid of the *Dynasty*-like shoulder pads (no offense to the legendary Joan Collins, of course, but the pads are not quite as current as they used to be). The zippers were a bit rusty, so I had new zippers put in. I also had the waists on each one taken in a bit and voilà! The pieces were suddenly contemporary and ready for the next generation!

These Zandra Rhodes designs are my most cherished hand-me-downs from my mother! Paris and I recently wore them in a photo shoot with Terry Richardson.

The vintage and consignment stores I frequent the most:

Los Angeles:

The Way We Wore: They have great designer and non-designer sections, both carrying amazing clothes and accessories.

Shabon: The place for incredible dresses, tops and handbags.

New York City:

Fisch For the Hip: Great deals on gently worn designer clothing. Many stylists and editors consign their clothes here, so you know the selection will consistently be incredible.

Ina: I've found many current pieces that I missed out on or couldn't find anywhere else at Ina. Such a wonderful feeling to find!

Sample Sales

Living in New York City, the fashion capital of America, means I have access to some of the best sample sales in the world because most of the designer showrooms are here. In the traditional sense, sample sales are events held by designers or stores to sell "sample" merchandise intended to promote upcoming lines to fashion buyers or shoppers. But now, the term *sample sale* is used a bit more broadly, and can sometimes be substituted for what is really a warehouse sale, where designers or stores sell overstock items, returns and other products that didn't sell as well as they had hoped. These are amazing opportunities to find new, great merchandise at drastically reduced prices. And do not think you are at a disadvantage if you do not live in a metropolis like New York. There are plenty of sample-sale websites popping up, like the now-legendary Gilt and Rue La La. Plus, there are plenty of sample sales all over the country—just google the term *sample sale* and your location, and see what turns up.

I had the incredibly good fortune of stumbling upon one of the best sample sales you can imagine while I was just wandering through SoHo last year. I was walking down Greene Street and noticed a small, nondescript sign on a door that read: "Proenza Schouler Sample Sale." My heart began to race and I darted to the door like an Olympic sprinter. I walked in and checked in my

bag and phone (designers are very strict and don't want photos of
their often not-yet-released or exclusive items leaked online to the
general public). This sale, in particular, was stocked with so many
goodies I could not believe my luck.

There were pieces not only from the previous season, but items
from the archives—four, five, even six years ago. They also had
a huge selection of their staple handbags, the PS1, in virtually
every color. While these bags were still flying off the shelves of
department stores at full price, they were being sold at the sam-
ple sale for up to 60 percent off! I was surprised to see current
collection pieces in the sale, but I did not ask questions and just
ran amok, racking up items I was really in love with and knew I was
getting at a steal.

Sample sales can be tricky. Purchases are usually final sale and
merchandise is limited, so there's an overwhelming sense of
"Must buy now!" and competition floating through the air. But the
best strategy you can have when you walk through the door is
to know your style, know what works best for your body and be
familiar with the designer or store, if possible. Had I not known
the PS1 bags were current items that were worth so much more
than they were being sold for at the sale, I might have let them
slip through my fingers. But knowing their retail value increased
the appeal, and I ended up with a few great investments. If you
have some knowledge of what you are looking at when you sift
through the racks of a sample sale, you will be much better pre-
pared to say "yay" or "nay" and pick up pieces that work with
your 3-6-5 and not against you.

Know What
to Wear.
Everywhere.

GIRL TALK

"Fashion Can Be Bought. Style One Must Possess."

EDNA WOOLMAN CHASE

Your Love Life

What to wear whether you're looking for everlasting love...or the last impression you'll leave when you're moving on to the next.

FIRST DATE

First impressions are everything on a first date. We are visual creatures by nature. The tried-and-true way to catch a fish is to show it something enticing on a hook.

When you're on a date with someone, you are looking to see how he or she would fit into the different aspects of your life. I imagine that a guy would be wondering, *Would my friends like her? Could she fit in with my family? Is she high-maintenance?* and, of course, *Do I want to take those gorgeous clothes off?* My goal is to let him know that I can hang with the guys, I am someone he could introduce to his family, and that I don't take six hours to get ready. And, of course, I aim to look attractive but not overtly sexy. That said, my go-to first date outfit is (drumroll, please) leather pants or skinny jeans with a not-too-femme but pretty top and a fitted blazer with heels.

174 If leather pants aren't for you, super-dark skinny jeans will work, too. Both are a sexy step up from the standard jean. On top, pick a color that complements your eyes or go neutral, but steer clear of anything too trendy. The goal is not to look too fussy, as if you didn't try so hard. A pair of classic black heels would be perfect but be sure that they've been broken in and you're comfortable walking in them. There is nothing cute about wobbling around like a newborn fawn because you can't walk in your shoes.

MEETING THE PARENTS

It's exciting, but definitely a little nerve-racking when the relationship with your honey hits the next level. At that moment, when he pauses, looks you in the eye and says, "I'd like to introduce you to my parents," you go back and forth in your mind between wondering what the heck you are going to wear and…well, wondering what the heck you are going to wear.

Don't freak out. This is a great opportunity to meet those who mean the most to your beau and show them your best self, both inside and out. You should express who you are from both a personality and a wardrobe standpoint. The true self that says, "I am responsible and intelligent and sweet." Not, "Earlier today, I went to a casting call for *Millionaire Matchmaker*."

I usually opt for a modest dress with either capped or three-quarter-length sleeves, in a respectable length (either close to or at the knee). A cardigan or tweed jacket would be a nice accent piece. You can never go wrong with a classic Chanel, but many designers high and low create versions of this jacket at different price points. I frequently go to my Chanel-inspired tweed jacket by Marc Jacobs. You can keep it youthful by choosing one with fun accent colors like fuchsia and teal.

Modesty and class are the key words here. Save the stilettos for another time. This occasion calls for a sturdy heel or a fancier flat in patent leather or cap toe.

I also make do with minimal jewelry. Simple earrings, such as studs or small hoops, and maybe a ring or two if you normally wear them every day. Fret not and enjoy the evening. The parents will love you, and hopefully your boyfriend will notice that your wrist could also use a Cartier Love bracelet or two.

BREAKUP DATE

He loves me. Me loves him not. Who hasn't been there? Breaking up is hard to do, but that doesn't excuse doing it via text, email or tweet. Meeting the poor guy in public is sometimes what's best in the worst-case scenario.

So, what to wear to such an occasion? Ladies, if we must, here is what we must…wear: First, a super-soft sweater. After all, your soon-to-be ex is going to need a comforting shoulder to cry on (even if it is for the last time!). It can be a cable-knit pullover or cashmere cardigan but, please, not boyfriend-style…that would just be cruel.

176 This display of emotion from your now-former guy might make you a little misty-eyed. Even though he's not for you, you're not made of stone. Wear waterproof mascara—Lancôme Hypnose is my go-to—just in case you shed a tear or two.

Keep the conversation civil, maintain your cool and don't let things drag on too long. Soon you'll be walking out the door in sky-high heels (because you are so above acting like a crazy girl) with your chin up and your dignity intact.

Last but not least, definitely don a pair of jeggings under that cozy sweater. It will give you extra room to breathe after calling in the reinforcements (aka your besties) for a post-breakup pizza and ice cream party.

At this point, feel free to change into your UGGs and mismatched sweats. Also be grateful that (1) you are never, ever, ever getting back together and (2) your mascara is not running down your décolletage.

What to Wear Here, There, Everywhere

SHOPPING SPREE

The shopping gene has been passed on in my family from generation to generation. With years of hunting-and-gathering experience

in my DNA and under my belt, I've learned some tricks along the way that can turn a store outing into a mini–fashion show, sans backstage drama.

When you're breezing through a boutique or a sample sale, or thumbing through the racks at a department store, it's important to wear clothes and shoes that you can wiggle in and out of without any muss or fuss. Over-the-knee boots look hot, but they won't seem so amazing when you've had to pull them on and off after several trips to the dressing room. Opt for lace-less, buckle-less shoes that you can slide in and out of with ease.

I also like to wear a nude convertible bra that goes from regular to halter to strapless with a few adjustments. Even though I may start the day looking for a shirtdress, I might get wrapped up in trying on strapless peplum tops. To that point, a maxi dress can be your best shopping friend because it's one item to go on and off and you don't have to mess with zippers or buttons. Anything that makes undressing and redressing over and over again less of an ordeal will not only make the experience more enjoyable, but it will help you make better decisions because you'll be in a better mood!

I always keep silky half slips handy in both nude and black. These little pieces of lingerie will save you from embarrassing moments whether it is a sheer dress or one that picks up with the wind. You may not wear them often, but you will sure be glad that you have one when you need it.

178 Lastly, stay away from heavy makeup that day. It can accidentally ruin the amazing cashmere sweater from the sale rack that you've just fallen in love with.

LIFE'S A BEACH

Whether I'm at a beach party or lounging poolside at a hotel, my goal is for what I'm wearing to stay true to my style, even though I'm wearing hardly anything at all. Just like my love for the classic blazer, I am drawn to basic bikinis to accessorize around. Shoshanna and J.Crew carry a wide variety of simple suits in brilliant colors.

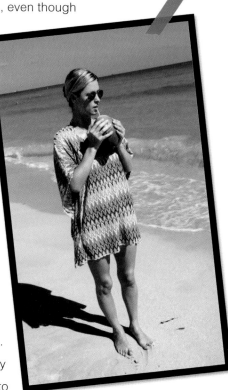

I prefer a string bottom because they work well with my body type. On top, I'm a fan of twist bandeaus and halters, too.

I can't understand why women like to sunbathe decked out in jewelry. It's uncomfortable and creates hideous tan lines. If you must bring some bling to the beach, do so delicately and opt for a tiny necklace or a few small rings.

Tunics are a must-have item for fun in the sun. Thanks to designers from Pucci to Tolani to Tory Burch, it's easy to be ready for anything from day to night. I use a tunic as a bathing suit cover-up, belted over shorts or over a tank dress with jeweled sandals or gladiators. Plus, tunics are easy to pack because they hardly take up any space and most are virtually wrinkle-free.

LA LADIES WHO BRUNCH

Even when my schedule is completely jam-packed, the one thing that's always inked on my calendar is a morning date with my girlfriends. I love getting together with my cousins and pals for a round of French toast and fresh juice.

Brunch is supposed to be a leisurely and relaxed time and I like to dress the same way. My vintage Levi's jean jacket goes with every sundress or floor sweeper skirt and tee. Free People also creates clothes with the perfect balance of boho-meets-city. Most of their pieces are under $50 and easy to mix and match.

If I'm going somewhere very casual, I'll wear flat leather sandals. However, if there are tablecloths involved, I'll stay comfortable but raise the bar with a wedge. Voilà! Brunch is served.

Ladies, this is unacceptable behavior. We are better than this.

RUNNING ERRANDS

Sometimes a run to the grocery store, dry cleaners or dentist just sounds like so much effort. It is all too tempting to say forget you to fashion and roll out in sweatpants and a sloppy shirt. We've all done it. You slide into your security blanket shoes—aka UGGs—and don't even bother pulling your pant legs all the way out. Don't pretend that you haven't done that, too!

As painful as it might sound at the time, you've got to pull it together—just a little. Take two minutes to throw on a loose-fitting button-up or boyfriend cardigan and a

180 pair of leggings (which are just as comfortable as sweatpants and you know it). Ditch the fugly boots and in their place put on shearling-lined smoking slippers or ballet flats. You can do this. We are in it together. And that wasn't so hard, was it?

SWEATING IT OUT

When it comes to working up a sweat, I love to take advantage of the outdoor obstacles that New York's Central Park and the canyons in Los Angeles have to offer. There is something to be said about what walking, running and hiking in nature does for your mental state when you're working on your physical.

But just because you're kicking up dust doesn't mean any fashion sense should be left behind in it. Hands down, Lululemon makes the best stretchy pants. I like to mix it up, depending on the weather, but I buy them all: cropped, long, yoga fit or tight. In terms of fashionable but necessary staples like windbreakers and sneakers, Stella McCartney for Adidas is amazing.

It is really easy to find basics like tank tops and workout tees at places like H&M and Target. Personally, I would rather spend a little more on staples that I love and save on the easy-to-find and replaceable items. Especially those that I sweat in.

Let's be honest—nobody picks up a pair of training shoes and says, "Ooooh these are darling!" (at least nobody I know). I'd rather not draw attention to these shoes by choosing ones with neon colors and flashing lights. Instead, I go for an all-black or -gray shoe that supports the rest of my outfit—and my high arch.

Keeping it casual but cute for Coachella.

CONCERTS

Madonna says, "Music makes the people come together." And it does. But concerts also have a tendency to separate you from those you arrived with, as it did for my sister and me in 2009 at Australia's Summafieldayze music festival. I wore an Isabel Marant day dress and, while cute, it didn't exactly stand out in a crowd. Since then, I've opted to wear skinny jeans in bold colors to crowded venues. That way, I'm easily spotted by my friends should we drift apart (and it's much less obtrusive than carrying around a balloon).

I spend most concerts standing up, so flat, low booties or short boots keep me comfortable and keep my toes safe from getting stepped on. Artists are the ones who control the temperature in the stadium (did you know that?), so it can be stifling hot or freezing cold depending on whose show it is. I like to wear a breathable, short-sleeved shirt and jeans or leggings that stay above my ankles (you've seen what those floors look like, right?). A light kimono-style jacket or wrap can double as a scarf, be tied around your waist or folded into your bag if you don't need it during the show. Do not make the mistake of bringing a clutch to a concert. Choose a crossbody bag, ideally something that can survive beer spillage by passersby.

No fuss hair is a must for music festivals.

182 *VEGAS AFTER DARK*

What happens in Vegas…shows up all over social media outlets and, in some cases, that includes TMZ and Page Six. There is a time and a place for everything and when it comes to all things over the top, all signs point to Sin City.

I like letting out my inner showgirl in Vegas. Going glam in a sequined dress or fringed top is half the fun of being a girl. But some ladies take the anything-goes attitude a little too far, in my opinion. Just because the city is known for working girls, doesn't mean you should dress like one. Do not wear anything resembling a clear acrylic platform heel. Ever. Gamble on the casino floor, not with your fashion. Adhere to the same rules you would anywhere else, just let the hemline get a little shorter and the sparkle a little brighter. Do take full advantage of the fact that wearing crystallized peep toes to dinner is acceptable here! I make it a great excuse to take out my blinding, blinged-out, Christian Louboutin peep toes.

I have a special love for Las Vegas. It is one of my favorite places in the world. It really is. Vegas embodies everything I love about travel: amazing hotels, restaurants with delicious food, state-of-the-art spas, great shows, fun nightlife and, most important, fantastic shopping! I fell in love with Vegas at a young age. When we were younger, my parents would take my sister and me to Las Vegas when they

had business meetings there. We would stay at the Las Vegas Hilton in my grandfather's suite. We absolutely loved going there!

Every night as kids Paris and I would eat at the Hilton's Benihana restaurant—every child's dream restaurant because they cook on the stove right in front of you. We would slink into the kitchens and watch the chefs prepare room service, go into the bakery and make our own cakes and pastries, hold court at the hotel arcade, and put quarters in the slot machines and run away before security spotted us. To us, Vegas wasn't just a playground for adults. When Andrew Lloyd Webber's *Starlight Express* was playing, we would beg our parents to take us to see it every night. We never got tired of it. During the day we would sneak into the theater, put roller skates on and skate through the stage, reenacting scenes from the musical.

Gamble on the casino floor, not with your fashion.

Years later, when I started my own fashion brands, I would travel to Las Vegas a few times a year for the apparel trade shows. I've probably spent at least fifteen New Year's Eves there (going back to when I was a child). One of my favorite trips to Vegas was for my twenty-first birthday party at the Hard Rock Hotel right off the strip. All my friends and family flew out. I stayed in the infamous bowling alley penthouse with all my girlfriends. It was basically a big weekend slumber party. We did what most twenty-one-year-olds do in Vegas—danced and gambled all night long.

No matter where you're heading to, don't forget where you're coming from. Stay true to your tastes and don't compromise your style fingerprint when dressing for different places and occasions. Even if you're going through a bad breakup or to a bad-girl bachelorette party, you can still be a good dresser!

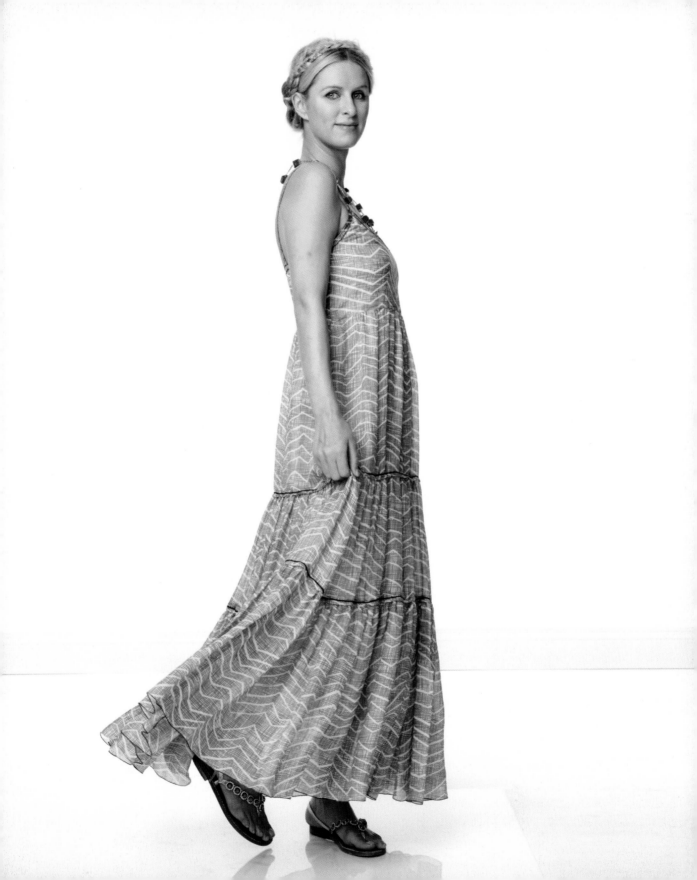

MOTHER KNOWS BEST

Lessons I Have Learned
from my mother, Kathy Hilton

" I Go from a Full Working Day to Making Sure I am Home for Dinner with my Kids. I Couldn't Do that in a 10cm Miniskirt but I am Not Going to Resort to Sweatpants and an Old T-shirt. "

DONATELLA VERSACE

There was no way I could pen a style book without dedicating at least one chapter to my mother. I could fill countless pages with the indispensable advice my mom has passed down to my sister and me and, let me tell you, it was a huge challenge trying to condense the highlights of my mom's lifelong guidance into just a few key pieces of wisdom. I hope you take away as much from my mom's suggestions as I have and are able to incorporate them into your 3-6-5 lifestyle. We may not always like to admit it, but the old saying really is true: Moms know best.

Dress for Your Role

My mother wears many hats. I could mean that literally but in this case I am actually being figurative. My mom always dresses for the occasion: Whether her role is soccer mom, businesswoman or wife, she dresses appropriately for each situation while always remaining true to her personal style.

My mother taught me how important it is to dress the way I want to be perceived. There is such a stigma attached to being a young celebrity, and I never wanted to fall into a stereotype and be judged negatively by my appearance. I always wanted to be thought of as classic, classy and elegant and, from a young age, I aspired to be taken seriously. I consider my roles to be daughter, businesswoman, girlfriend and friend. It means a lot to me that the way I dress embodies who I am. If I do not feel that I am being true to myself in the way I dress, then I do not feel that I am fully committing myself to the various roles I fulfill. We all have those days when the last thing we want to do is put on our business attire. But if I have a business meeting, I will force myself into a crisp blazer and heels, even if I feel like wearing sandals and leggings (or staying in PJs). I know dressing the part instantly transforms me into the person I need to be at that particular moment.

Dressing the part instantly transforms me into the person I need to be at that particular moment. ☺

Settle on a Signature

Let's go back to my mother and her hats for a minute. My mom's signature items are hats and visors. She loves them, and for good reason! Hats and visors are fashionable and functional: They are comfortable, stylish and they have the great bonus of protecting your skin from harmful UV rays. I do not think it is a coincidence that my mother has the most stunning skin imaginable! Thanks to Mom and her hat habit, I have grown to think it is pretty cute to have a quirky, fun signature item that makes people think of you. For me, anything cat-themed is a must-have. In case you couldn't tell, I *love* cats. When I see kitties emblazoned on a clothing item or accessory, I have to have it. Marc Jacobs and Charlotte Olympia's kitten flats? Sold.

Save Hemlines

Mom has always warned me that I might change my mind about the length of a skirt or dress. While a micro-mini may seem totally appropriate now, as you mature you may not feel quite as comfortable showing that much leg. You may change your mind

190 about the length of your pants, too: You might decide to start wearing high heels with a pair you once reserved only for flats, or vice versa. My mother advises that, when you get anything shortened, always leave extra fabric so you have the option to lengthen your pieces again. It may be tempting to kiss the option of extra length goodbye, but having the flexibility may add years of wear to wardrobe items you may have otherwise tossed aside.

Dress for a Sunshiny Mood (Even If Your Parade Is Being Rained On)

If you have been in a slump, a funk or an all-out state of despair, or if you are just having one of those days, do not dress the part. Just because you are feeling blue does not mean you should express this in your outfit. No matter how she feels, my mom always puts on a fresh, cheerful shade of lipstick and a bright nail polish hue to instantly rev up her mood. I tend to wear a lot of black, so adding a touch of yellow or baby blue clears the fog of a bad day and eventually the sunshine in my palette perks up my spirit.

Scent of (Not Every) Woman

When I was growing up, my mom wore only Quelques Fleurs from Paris. As a child, I associated that scent with safety, beauty and home. Now it is the only fragrance I wear. Although she collects perfumes from all over the world and has since gravitated toward other scents, my mom generally sticks to just one per season. Still, to this day, I think of Quelques Fleurs as her signature scent and wearing it exclusively makes me feel that I'm carrying on some kind of deliciously scented tradition.

Give Your Girls a Lift

The right bra can make or break a great outfit. If you have proper support, your whole posture shifts and you can look like a totally transformed, more confident (and slimmed-down) lady. Make the time to get fitted for bras. My mom always directed us to Nordstrom, where experts fit you quickly and expertly. There is no reason to spend big bucks on a bra, but it is worth a reasonable investment. There is also something about wearing pretty underwear, so be sure to pick out something that makes you feel special!

Fake Is Fake

My mother has really drilled this rule into me and I stand by it wholeheartedly. It is unfair to buy an exact replica or knockoff of *anything*. That includes watches, purses, wallets, shoes, clothes and more. Designers spend much time and artistry creating and designing. They put an unbelievable amount of money and time into advertising campaigns and marketing. It really is stealing when people manufacture knockoffs and it takes jobs away from those who could benefit from being employed by real-deal designers. There are many side effects of buying counterfeit items that you may not even be aware of. Knockoffs are often created in sweatshops that violate basic human rights. In addition, many of the manufacturers involved in counterfeiting engage in human trafficking, abusing children and exploiting their labor. This is why it's important to buy the real thing, so as not to inadvertently contribute to these crimes.

If you truly love something that is out of your budget, keep an eye on eBay or check in regularly on consignment shops for a secondhand option. Be sure to always check a seller's history to ensure that the seller has a decent reputation. Don't make the same careless mistake I did years ago when I bought a limited-edition Dior bag on eBay. I did not investigate the seller in any

way and when the bag arrived, it was lined with *newspaper.* I was
stuck with the bad bag—it was not returnable—and never made
that mistake twice. A friend of mine bought what she thought
was an authentic Hermès bag online, but, when she took it to
be cleaned, the Hermès store refused. Apparently, Hermès will
never authenticate an item. They will simply decline to clean it if
it is a fake.

Buying counterfeits can happen to the best of us and sometimes
we make honest mistakes. But to minimize the possibility of this
happening, take a close look at the details of what you love about
a higher-priced item and find a similar one in a lower price range.
There are so many fab designs available these days in every
price bracket. There is no reason to stoop as low as swooping
up a straight-up fake.

SOS

Save Our Shoes, that is! Thanks to my mother's insistence,
I replace the rubber on the soles of every pair of shoes I own. No
matter if they cost $25 or were too embarrassingly expensive to
admit in print, I always take the time to do this because it makes
shoes water-resistant and skidproof and, no matter what they
cost, they practically last forever.

I have a favorite pair of YSL booties that I have had for six years.
I take incredibly good care of them and I resurrect them regularly
by having them repaired when they start looking shabby and less

194 chic. Last year, a heel snapped off my right shoe while I was out and about in London! It was just like in a romantic comedy—I didn't know that could happen in real life! But I brought them straight to the shop when I got home and they are back on my feet and I am still standing in them today. If you invest the time, energy and a little money, shoes can seriously stand the test of time.

Do not think your shoes have to be designer brand to deserve tender loving care. I had a pair of cheap gladiator studded sandals in rotation for years. I had the rubber on the soles replaced several times because I loved them so much. I probably spent about the same amount of money on the new soles as the shoes themselves were worth. Despite my best efforts, I had to keep taking the fragile, cheap kicks in to get them repaired time and time again. Then, last summer, it was so hot outside that the bottoms of the sandals kept sticking to the pavement and eventually one of the soles just fell off! They did serve me well for years, which is far longer than they should have. And that may be another rule to live by: If the sole of your shoe declares independence from the rest of your sandal, it may be time to move on.

Don't Drain Your Dinner Date

If you are being treated to dinner out—by boys, friends, parents of friends, business partners, etc.—do not ever order the most expensive thing on the menu, even if you know your dinner partner can foot the bill. Opting for the pricey option is simply bad manners. It is not the type of impression you want to make on anyone. If people are taking you out, they clearly want you to have a good time, but having a good time does not necessarily call for lobster and Dom Pérignon. Opt for something on the menu that is equal or less expensive than your host's choice. This way, you will all enjoy the meal without leaving your host with a bad taste about your dining etiquette.

Let One Thing Be the Star

When it comes to style, pick one item of your ensemble as the focal point. Patrick Demarchelier was once photographing my sister, mother and me for a magazine. My mom and I started trying on jewelry provided by the stylist and were getting increasingly excited by the range of sparkly accessories. Patrick came up to us while we were prepping and said, "If you wear earrings,

196 wear nothing else. Let only one thing be the star." We never forgot that simple statement and we all abide by it to this day. You do not want your outfit, your makeup and your jewelry competing for the spotlight. After all, *you* want to shine through the brightest, so let just one item draw attention in your direction.

Dress Appropriately for Your Age

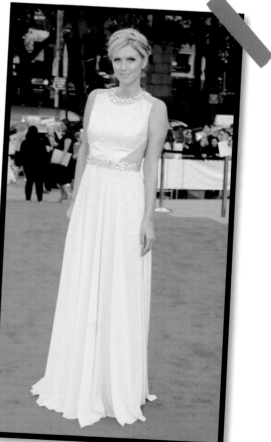

Proud daughter! Wearing a dress designed by my mother to the American Ballet.

Dressing your age is very important. There is nothing wrong with showing some skin and wearing sexy clothes at an older age, but it has to be done tastefully. There is nothing more tragic than a woman trying to dress like she is half her age instead of celebrating the age that she is. My mom doesn't try to compete with Paris or me. Dressing for an age bracket much lower (or higher) than your own comes off as trying too hard to be something you're not. I think it is so important and beautiful to embrace your age. I have had to come to terms with the fact that I can't get away with certain things that I once wore in my early twenties. Sometimes, you just have to know when to hang it up or fling it into a donation pile.

It Is Always Better to Be Underdressed than Overdressed

There is nothing quite so mortifying as walking into a room where everyone looks cool and comfortable and you look like you are going to the prom. My mom's less-is-more rule applies here, too. If you are unsure about a cryptic dress code, dress down and keep it simple. There is a lot of power in accessories. Even if your outfit ends up being a notch too informal for the occasion, a good pair of chandelier earrings or a statement necklace can save your look completely.

Embrace Style, Not Set Looks

Even if I were drooling over the carefully contrived outfit on a store mannequin, my mother never encouraged me to buy the whole look from head to toe—and for good reason. The last thing you want to do is walk around looking like a mall clone by copying the matchy-matchy style you saw in the window of

198 your favorite store. Mix up the carefully contrived looks you see in stores and on models and make them your own. There is nothing fashionable about being a label addict. Have your own fashion identity by creating looks that are exclusively "you."

A few months ago, I wore a star-emblazoned Dolce & Gabbana dress with black pumps and a clutch to dinner with my parents. The next night, my aunt Kyle invited me to come with her to Andy Cohen's *Watch What Happens Live* on Bravo. An invitation to tag along turned into a spot as their guest bartender and, since it was last minute, I hadn't planned an outfit. I loved the Dolce & Gabbana dress that I had worn the night before but I wanted a more casual look and the short-length minidress was a bit too sexy. Rather than start from scratch, I rolled the tight dress up like a top, added leather pants and a blazer, then suddenly felt much more like me. Taking ownership of the outfit was the key to reclaiming my own style and feeling comfortable in an unexpected on-air moment.

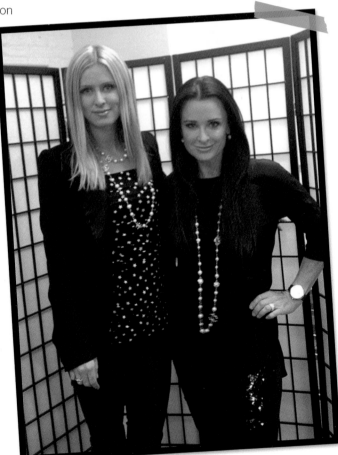

Appreciate Individuality and Have an Open Mind

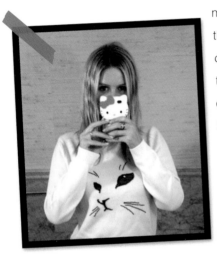

My mom always says, "You may visit a modern style house, and modern decor may not be for you, but always appreciate the beauty in it and have an open mind." This same principle applies to fashion. You may not understand why the girl in line at Starbucks chose the dress that she did and you may not be a fan of a certain style that is trending. The real beauty about style is that it is entirely about individuality. So even if you cannot wrap your head around why someone likes something or thinks it looks good, accept that she does and appreciate her gutsiness in expressing that to the world. I am aware there are items in my wardrobe that are not for everyone (hello crazy cat face sweaters!), but they make me smile! It's okay if your thing isn't everyone's thing. That's what makes the world we live in so interesting and eclectic.

Sleep on It

Sometimes the shopping rush gets the better of us, and we want to charge everything to our credit card immediately. But my mom always emphasized that you are under no obligation to buy

200 something the same day you find it. If she sees something that she isn't quite sure about, she simply puts it on hold. If she wakes up with it still on her mind, she figures that she'll probably still be in love with it and it is a safe bet that she can go back for it and not experience buyer's remorse.

Snip It

My mother recently bought a gorgeous purple J. Mendel suit for an event at Buckingham Palace. When she went on a mission to buy shoes and accessories, she smartly snipped a piece of the fabric from the hem and brought it with her. My mother taught me that, when she was my age, women followed rules about exactly matching their shoes to their belts to their dresses. Luckily, rules are much more relaxed now. Coordinating accessories is not about unearthing an exact match but about finding a similar shade and blending it well with like colors or neutrals. Snipping an unseen part of the hem of your outfit makes finding complementary tones a snap.

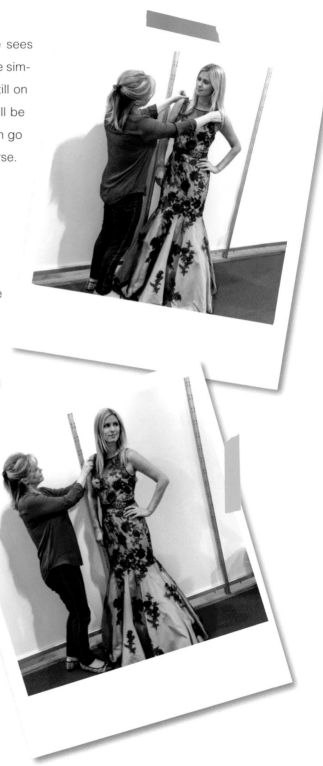

Not Everything But the Kitchen Sink

My mother and I are not big fans of the often-seen, top-to-bottom beaded look. We think it's just too much. She taught me that if your outfit is dressy on top, keep it simple on the bottom, and vice versa. It is easy to get carried away when you really love a particular fabric, color, texture or print, but the key to wearing something striking or a statement piece successfully is to balance your look to avoid the too-much taboo.

These snippets of advice are gifts that my mother has given me throughout the years. Her advice has helped me develop my own personal style. While writing this book, I was struck by how my views on fashion and style have evolved from things I have learned from my mother. I hope you find her insights as helpful as I have!

ALWAYS ON TREND

Being a Kind, Generous
and Honest Person
Never Goes Out of Style

When I set out to write a book about style, I immediately knew how it would end. I tried to keep any spoilers out of the introductory chapters, but it is finally time for the big reveal. And this is the part of the book that is closest to my heart and the core of why I wanted to take on this project in the first place.

We have covered quite a bit of style-related ground in the preceding pages, but now we need to recognize what will truly get you through any variety of seasons, occasions, events and travel destinations. While I hope I have prepared you for what you can wear to weather all of life's more interesting moments, it's also essential to know how to *be*.

In the beginning of this book, we discussed the importance of making a great first impression. But now that we are at the end, it is up to you to figure out how to leave a lasting positive mark on the world around you. You can look like a sweetheart in a pastel,

eyelet peplum dress, but the minute you bark at the barista for for-
getting your latte, you may as well be wearing a pointy black hat.

It takes more than glitz and glamour on the outside to really have "style" and shine like a Harry Winston diamond. So what exactly does that mean? To me, being "stylish" means being the kind of person I am proud to look at in the mirror every night when I wash the makeup off my face. It means feeling truly confident that the way I treat people throughout the day is the way I want to be treated. It means expressing gratitude for all that I have been lucky enough to have while giving as much as I can to help those who are less fortunate. And, above all else, being stylish means being 100 percent authentic to the person I am at heart, and knowing that that person is worthy, loving and capable of having a positive influence on the world around her.

It is up to you to figure out how to leave a lasting positive mark on the world.

I hope you leave these pages with a renewed sense of purpose to *do* good, not just to look good. I think we have all met girls (and guys!) who seem to have perfect, tanned, toned bodies and expensive, stylish clothes, but are masking some less-than-ideal internal qualities underneath those facades. As I see it, to be a truly beautiful person, you have to be kind, caring and take pride in who you are. Does that mean you should shun the style tips you have read in the previous chapters, cancel all your fashion magazine subscriptions and cover every mirror in the house? Definitely not. But I do encourage everyone to have some broader interpretations of what "beauty" and "style" are and to

206 learn how to incorporate them in all sorts of ways that make you feel fulfilled inside, so you are radiant on the outside.

All this is to say that I want to leave you with one last 3-6-5-themed guide. These are my all-purpose 3s, 6s and 5s that get me through life's tough times when the solution isn't as simple as grabbing the right belt or wearing the most appropriately sized handbag. I hope this guide inspires you to connect to what is most meaningful in your own life and to find what inspires you to be a better, stronger, kinder human being. While I can't promise that incorporating a specific brand of heels into your wardrobe or swapping one pair of earrings for another will ever make you a happier person, I can almost guarantee that creating and following your own set of core values will immediately brighten your outlook and light up your life.

Without further ado, here is my personal 3-6-5 guide for any occasion. I encourage you to create your own. All you'll need to get started are three role models who inspire you, six quotes to keep you grounded and five goals to keep you accountable.

I hope this guide inspires you to connect to what is most meaningful in your own life.

3: My Three Role Models

1. DIANE VON FURSTENBERG

I have been a fan of Diane's for as long as I can remember. She is beyond inspirational and she has motivated me in all facets of my life, from the personal to the professional. The quintessential power woman, Diane built an enduring, successful, iconic brand

that has been at the forefront of fashion since she created the wrap dress in the 1970s. Rather than stop at the wrap, Diane forged on to develop a complete lifestyle brand with eyewear, shoes, fragrances, luggage, bedding and more. On top of all of that hard work *at* work, she dedicates herself at home to being an amazing mother, grandmother and mentor to many. I think she empowers women from all walks of life to really go after their dreams, no matter what they are. You don't have to be a designer or a fashionista to appreciate and learn from the ways Diane has realized her goals through some serious dedication, courage and resilience.

208 There has been so much debate in the media about whether or not women can truly "have it all." Can we fall in love without sacrificing our careers? Can we be mothers and still strive to be CEOs? Is it acceptable to be emotional and vulnerable at some points *and* be a tough cookie when the situation calls for it? I think Diane is living proof that *of course* we can be and do all those things. To me, the key is one word: balance. Diane exudes a serene sense of equilibrium that I think is incredibly important. Maybe this is the Libra in me talking—after all, we are represented by the image of a scale!—but I cannot stress strongly enough the importance of finding balance. Being able to incorporate business and pleasure, work and play, family and career is so important to health, happiness and success. I credit Diane for teaching me the beauty in that.

2. MY SISTER

My sister Paris is someone I really look up to. She has been through so much—the good, the bad and the ugly—yet she has somehow always managed to keep a smile on her face.

Besides being one of the most positive people I know, she is also one of the hardest-working. Paris has built an incredible empire for herself (she currently has seventeen product lines), and she has done it all through her hard work and dedication. From Paris Hilton footwear to eyewear to clothing to perfumes (over *fifteen* of them!), she has taken entrepreneurship to another level. On top of all that,

she has tackled television, film and music, and she has never been afraid to take real risks. Paris is one of the few people I know who truly does not give a damn what anyone else thinks. I know people say that pretty frequently, but my sister simply refuses to live by anyone else's rules. She lives her life unapologetically, and for that reason alone, she will always be one of my top role models.

3. MY FATHER

If you have not noticed by now, my family means everything to me, and so it should come as no surprise that my father, Rick Hilton, is another huge role model in my life and one of my personal heroes. He is an amazing dad, husband, businessman, friend

and all-around person. He has worked so incredibly hard for everything he has and he has never taken the easy route. My dad could have simply chosen to work for my grandfather. Instead, he chose to go out on his own. He runs a successful real estate firm, Hilton & Hyland, in Beverly Hills.

My father always taught me and my siblings the value of a strong work ethic. We were raised to know that everything we wanted was to be earned and not given to us on a silver platter.

He always stressed the importance of finding a job and making our own way. We were all expected to make a living and carve out our own careers.

I got my first job when I was fifteen years old as an intern at *Hamptons* magazine, and quickly learned what it meant to *work*.

210 Some of my duties included taking lunch orders for the staff, dropping off and picking up film, mailing magazines to the advertisers and, yes, taking out the trash. Without my father's leading example and guidance, I could have easily ended up like so many of the privileged kids I grew up with—spoiled and entitled, with no real sense of fulfillment, never knowing what it feels like to earn or accomplish something. I am forever grateful to my dad for teaching me the importance of hard work.

I am forever grateful to my dad for teaching me the importance of hard work.

6: My Six Style Quotes to Live By

1. "FASHION IS THE ARMOR TO SURVIVE THE REALITY OF EVERYDAY LIFE."

Bill Cunningham

Growing up in New York City, I walked home from school all the time. It was quite a trek from Convent of the Sacred Heart on 91st Street and 5th Avenue all the way home to the Waldorf Towers at 50th Street and Park Avenue. But while forty-three blocks may seem like a long way, I didn't mind at all. Time flew by as I window-shopped and gazed longingly into all the designer stores.

Bill Cunningham, the *New York Times*'s "Man on the Street," is a 211
legendary fashion photographer, primarily known for his candid
street photography. His full-page "On the Street" column runs
every Sunday in the paper's Style section, and he recently had a
documentary made about him called *Bill Cunningham New York*.

Bill is a spritely, white-haired, eighty-four-year-old man who is
always outfitted in a royal blue cardigan and khakis, and he has
become a New York street fashion icon. It is a major compli-
ment to be photographed by him, since he doesn't shoot people
based on their look, wealth or status in society. He bases his
shots purely on people's individual style.

I would often bump into Bill, usually at the corner of 57th and
5th—otherwise known as fashion mecca Bergdorf Goodman—
on my walks home from school. He would typically be at the
corner, shooting stylish people at random as they walked by.
I had no idea who he was at the time, but later I started spotting
him in the front row of all the major fashion shows. But Bill is still
incredibly down-to-earth—in fact, I just saw him the other day,
biking down 5th Avenue.

I love this quote from Bill for so many reasons. According to Bill,
"The best fashion show is definitely on the street," and I couldn't
agree more. Bill believes that despite how frivolous some people
might think clothes and accessories are, they serve a true pur-
pose and provide a refuge and protection in a way.

This quote reminds me of that great scene in *The Devil Wears Prada*
where Meryl Streep as Miranda Priestly schools Anne Hathaway's
Andy Sachs on the importance of fashion when the latter refers to
it simply as "stuff."

212 "That blue represents millions of dollars and countless jobs," Miranda says, referring to Andy's blue sweater. "And so it's sort of comical how you think that you've made a choice that exempts you from the fashion industry when, in fact, you're wearing the sweater that was selected for you by the people in this room. From a pile of 'stuff.'"

I don't think I was the only one silently cheering the "Devil" from my theater seat. In a way, Miranda reiterates exactly what Bill means when he refers to fashion as armor. We are not just talking about sweaters and jackets and purses and shoes when we discuss "fashion." We are talking about a way of presenting ourselves to the outside world that is all at once protective, therapeutic, expressive and, yes, fun. It is not just a matter of throwing on chartreuse genie pants for no real reason (though it can be if that is what you feel like doing!). It is all about selecting how you want to exist in an outside world that can sometimes be scary, depressing and dangerous. It is all about deciding how you want to be you. And that is way deeper than some frivolous "stuff."

2. "ALWAYS DRESS LIKE YOU'RE GOING TO MEET YOUR WORST ENEMY."

My girlfriend and I recently hit the town for a super-casual Mexican dinner. We had scheduled a late meal, around 9 p.m.,

so I had some time to kill before meeting her at the restaurant. I was in the midst of packing for a trip to Europe so all my clothes, shoes and racks were displayed perfectly. To kill the time, I decided to play dress-up (this decision will make perfect sense to you when you hit quote #6).

I blow-dried my hair and styled it with some beachy curls. I applied smoky cat eyes, slipped on a sexy black lace, lingerie-inspired dress, and put on my favorite cutout Alaïa strappy heels. I knew I was way overdressed for a casual din with a friend, but I didn't care. When I walked into dinner, my girlfriend laughed, and asked, "Did you get all dressed up for *me*?"

"Yeah, pretty much!" I declared.

After din, we decided to meet our other friend for a drink in SoHo. We hung out for a bit and chatted, and as I was leaving the bar, guess whom I ran right smack into. My very. First. Boyfriend. Beyond that, he had been my everything at sixteen.

"Hi, stranger. Long time no see," he said. I smiled, said hello and then I turned around and got in a car to go home, feeling as if I had just had one of those giddy girl moments. It's funny how things like that happen. And it just goes to show that you never know whom you are going to bump into.

This gem of a quote is often attributed to Kimora Lee Simmons, and I think it is a great rule to live by. It isn't that I condone making enemies or treating people badly—quite the opposite! But I do believe we all have those certain people in our lives who we feel have wronged us in some way (so many exes are coming to mind, am I right?), and there is nothing we want more than to run into them while looking our absolute, drop-dead gorgeous best.

214 I particularly appreciate that this quote is not about waiting for that random chance encounter or a mutual friend's wedding or an "accidental" run-in outside your ex's neighborhood grocery store ("Oh, hey, I didn't know you shopped at this Whole Foods…"). Instead it implies that we should not wait around for opportunities to look our best—we should look our best as often as we can. And, no, I am not talking about making sure you leave the house with a full face of makeup every time you check the mail (unless that is what makes you feel fabulous). It is about making sure you *feel* like the stunningly gorgeous goddess you are, and if that means rocking a pair of six-inch stilettos to the grocery store and getting your flirt on with the checkout boy, then by all means do it. If it motivates you to pretend you might see an old flame or a mean girl who made your life miserable in middle school, then channel that energy into your look. But in the end, looking your best is never about pleasing or impressing anyone else. It is about feeling amazing in your own skin and exuding that confidence no matter where you go.

3. *"FASHION CAN BE BOUGHT. STYLE ONE MUST POSSESS."*

Edna Woolman Chase

You are probably sick of hearing me preach this by now, but it really is a quote I say to myself daily, especially when debating the merits of an overpriced maxi dress. If you had the time, budget and desire to do so, you could absolutely attend every show during Paris Fashion Week, sit front row and spend your life savings on the latest lines.

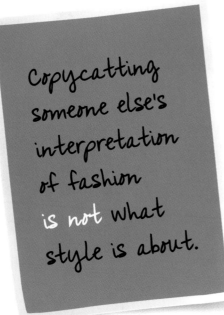

Copycatting someone else's interpretation of fashion is not what style is about.

Technically, you would rank pretty high on the fashion scale, right? But if all you did with those fresh-off-the-runway pieces was wear them exactly the same way you saw the models flaunt them, you would be doing just what I did when I dressed to impress (more like dressed to *impersonate*) Kate Moss. Replicating trends and copycatting someone else's interpretation of fashion is not what style is about, and, frankly, I don't know if it is what beauty is about, either. Of course you can look good in the newest Louis Vuitton, but if you are not comfortable in it, or you have not somehow incorporated a personal touch, it will be completely evident that you are not being you. Style is synonymous with individuality and, as far as I'm concerned, beauty is equivalent to being truly at ease in your own skin. I am definitely not saying it is an easy journey to get there, but the

216 more you can tap into what makes *you* tick, and the less you can prioritize what someone else has decided is the "it" thing of the moment, the easier it will be to embody real "style."

4. "PEOPLE WILL STARE. MAKE IT WORTH THEIR WHILE."
Harry Winston

I really believe you should always be the best version of yourself. Even if you are just running out to do errands, put in that extra five minutes to apply a little mascara and lip gloss or put on a pair of earrings. A lot can be accomplished in under five minutes, and that extra inch can go a mile.

I have sometimes had to take this quote quite literally, given the swarms of paparazzi that seem to trail my family. But I like the figurative meaning behind it: People will judge you, make assumptions, fabricate ideas about who they *think* you are. Rather than mourn the fact that others will inevitably give you looks you may not like and think thoughts you wish they would not, put your energy into looking and feeling your best and know that your best is *good enough*. If people are going to look and judge no matter how hard you try, then put your most fabulous self forward, and feel good about how you are presenting yourself. Whether that means wearing your most flattering dress or just smiling at a few more people on your daily commute (more on smiling later), giving people a reason to take notice of your confidence and conviction that you are great is the best thing you can do for yourself.

5. *"CINDERELLA IS PROOF THAT A PAIR OF SHOES CAN CHANGE YOUR LIFE."*

Unknown

Anxiously waiting to present at the FiFi Awards.

The easiest, quickest way to put on a successful front is to dress the part.

In 2001, my sister and I presented at the Fragrance Foundation's annual FiFi Awards. We were new to the spotlight and were so incredibly nervous to be onstage in front of such a prestigious crowd. There was a lot of pressure when it came to the presentation, and it was especially nerve-racking for me, because I was extremely shy and soft-spoken.

The organizer called us beforehand and said, "You have not made it until you have been onstage at Radio City Music Hall." While it was a nice sentiment, it did nothing but add to my anxiety! To say I was young, timid and intimidated is a huge understatement. But once I got all glammed up in my gleaming white dress, had my hair done and makeup applied, I adopted an air of confidence that took even me by surprise. Knowing that I looked my best made me *feel* my best and I was able to deliver when the moment called for it.

And that organizer really had a point—being onstage at Radio City still stands as one of my proudest moments.

I really believe that a single item of clothing or an accessory can change your life. But not because owning a pair of Christian

218 Louboutins or a Chanel purse will instantly improve your lot in life. Status symbols will never make you feel fulfilled. When I say an item of clothing can change your life, I mean you should never underestimate the power of a good confidence boost.

For example, you can make or break your chances of landing a job when you walk into an interview just by how you feel about yourself when you walk in the front door. If you glide in feeling poised and self-assured, you're going to exude that confidence when you meet your interviewer (and the receptionist, the doorman and the cute guy in the cubicle across the room). If you were not born into this world emanating self-confidence, then you must abide by another minirule I swear by: "Fake it 'til you make it." The easiest, quickest way to put on a successful front is to dress the part. If you feel comfortable, know you look your absolute best and, most importantly, are staying true to the look you love, you will automatically radiate a new kind of energy that is irresistible.

6. "PLAYING DRESS-UP BEGINS AT FIVE AND TRULY NEVER ENDS."
Kate Spade

If you need proof that playing dress-up begins at five—if not earlier—my mom has a treasure trove of embarrassing photos of my sister and me donning all sorts of sparkly costumes. But rather than bore you with the mortifying moments of my youth, I think it is more important to focus on why this quote is so

fantastic and so inspirational when it comes to putting together 219 your day-to-day style.

If you are anything like me, you have never gotten sick of playing dress-up. It is such a thrill to constantly reinvent your look, continually experimenting with, evolving and changing it. Madonna is a perfect example of someone who does that, and we should all be so lucky as to follow in her iconic footsteps.

If you think about it, assembling outfits and choosing accessories is nothing more than a grown-up version of playing dress-up.

And while so many of us have lost sight of the fun, freeing aspects of what it meant to play dress-up as a kid, those aspects of fashion and style are not forever lost. You can regain your playful attitude toward clothes if you just let yourself relax a little.

That is why the 3-6-5 system appeals to me so much. When you know in your head that you have these overarching categories to organize your wardrobe, it gives you opportunities to have a lot more fun creating outfits, almost as if you were dressing a doll or creating a playtime ensemble. You are forced to think of yourself in terms of different roles—the business You, the downtime/weekend You, the out-on-the-town-wining-and-dining You. It really inspires a sense of lightheartedness when you approach your closet with this touch of creativity. So never stop playing.

5: My Five Style Goals

1. SMILE AT A STRANGER EVERY DAY.

This is such an easy but epically important way not only to brighten someone else's day, but to instantly boost your mood. I am naturally super-duper shy, so it is way outside my comfort zone to flash a smile at someone I don't know. I think my quietness can be misinterpreted as standoffishness, but it really is just a serious case of the shys. I notice, though, that if I just force myself to look one new person in the eye each and every day and give her a genuine, heartfelt smile, something in the air automatically shifts.

There is a quote I absolutely love by Plato: "Be kind; everyone you meet is fighting a hard battle." There is so much truth in that simple statement, and I think we could all do so much good by just remembering and living by it daily. Even the people you encounter in daily life who seem especially infuriating are most likely coping with things you have no idea about. People deal with sick family members, job crises, relationship woes—all while going to work and grappling with the same little daily nuisances you face. And while you can't help every stranger or find out what each one of them is dealing with (without seeming a little too friendly), you *can* just send them a small, simple smile that lets them know they are not alone. I am working on it, and I encourage you to do the same.

2. ALWAYS WEAR SOMETHING THAT REMINDS YOU OF SOMEONE YOU LOVE.

My mother once bought me the most amazing gold, vintage Van Cleef & Arpels clover. She knew I collected clovers, so when she noticed it while shopping at an antiques store in LA one day, she felt compelled to get it for me. I wear it on a long, eighteen-inch chain that hits right in the middle of my chest. I love vintage pieces like jewelry or one-of-a-kind accessories that I know no one else has. The clover charm is timeless and reminds me of my mom every time I wear it. Looking down at it always makes me feel loved, knowing that she thought of me when she saw it.

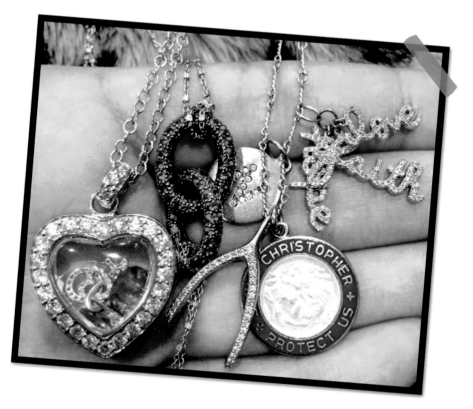

222 Whether I slip on a piece of jewelry that was a gift from my mom, or throw on a sweater that I scored in a friend's clothing swap, I always feel surrounded by good vibes when I have something to remember my loved ones by at all times. I guess it is sort of the equivalent of having framed photos of your family at work and in your home. It is just a constant reminder that no matter how stressful your day gets or how alone you might feel in a moment, you have people in your life who truly love and care for you, and will be there to support you.

3. GIVE. GIVE. GIVE.

I believe that being generous in any way can make a substantial impact on the world around you. Any time I need to reevaluate my closet situation, or I realize I have somehow stumbled back into hoarder status, I go through the pile of rejected items and immediately think of where to donate them. I am in the unusually privileged position of having companies and designers send me sample items, and sometimes those pieces either do not fit, or do not work into my 3-6-5 style. If I will not wear something as often as it deserves to be worn, I know there are plenty of people who will benefit from the regifting. But even if you have just a few things you are not using to their fullest potential, or you have some items that are not working into your 3-6-5 style, do some research and find out if there are organizations in your area that

accept donations. Dropping a box of clothes off at Goodwill or 223
a homeless shelter will not only free up space in your closet, but
will go a long way toward helping people in need.

Dress for Success is an incredible charity I have worked with that
changes the lives of disadvantaged women by providing them
with professional attire for interviews and jobs. You never know
how your now-too-small blazer can become someone else's lucky
interview blazer, or how the pants you are tired of might improve
someone else's odds of landing her dream job.

I also work with an organization called the Starlight Children's
Foundation, a global charity that teams up with experts to improve
the lives and health of kids and families all around the world. They
once organized an Easter egg hunt that I helped out with, and
many parents came up to me to say those few hours afforded their
son or daughter the opportunity to not be stressed or sad about
their life-threatening illness. For those fleeting moments, the kids
were caught up in enjoying and celebrating their lives. I cannot
even begin to describe how it made me feel to hear those words and to
be a part of something so special. I really think that opening your heart
and being charitable makes such a difference, whether or not the
people benefiting from it are able to articulate it directly back to you.

> *It is absolutely, 100 percent up to you to create a look that is truly unique to you.*

4. ALLOW YOURSELF ONE DAY A MONTH OF NO MAKEUP.

Back in chapter 10, I talked about the liberating feeling of going sans makeup whenever I vacation in Hawaii. It really does such wonders for your skin to let it breathe, but you do not need an island vacation to merit that kind of relaxation. I think it can be extremely beneficial to take a makeup break at least once a month, if not more often. Not only because it's good for your pores, but also because you get a chance to look in the mirror and remember what you look like au naturel. Do not get me wrong: I love a good Sephora session just as much as any-one else. Lipsticks and eye shadows and blushes can be so much fun, and learning to apply and wear makeup properly really is an art form. But when it becomes an obligation instead of an indulgence, that is when it might be best to take a break, at least temporarily. It just gives you a chance to feel like yourself again, and,

as I have repeated ad nauseam, true style is all about feeling good about who *you* are. So grab the mascara remover, apply a sooth-ing mud mask and enjoy the opportunity to rub your eyes without smudging liner all over your face.

5. FORGET EVERYTHING YOU HAVE LEARNED AND WRITE YOUR OWN STYLE RULES.

Are you surprised? I hope I have made it clear in bits and pieces throughout the course of this book that there is nothing I can tell you and nothing you can glean from a fashion magazine or runway show that will *give* you style. It is absolutely, 100 percent up to you to create a look that is truly unique to you. If you want to mix patterns, do it. If you are drawn to colors that clash, go ahead and clash them. If you feel like breaking every fashion rule you have ever learned, by all means, break them. This book was meant to inspire you, rev up your creativity and hopefully motivate you to make some substantial self-improvement changes in your life that go far beyond the four walls of your closet. If you close the covers on this guide and feel a little bit more in touch with who you are and how you want to convey that to the world, then I have definitely done my job. Now it's time to do yours and leave a lasting, stylish impact wherever you go.

xo ♡ Nicky

INDEX